To Lulu my mother
and Wenda my wife
who taught me to love women

SISTERS UNDER THE SKIN

NORMAN PARKINSON

St. MARTIN'S PRESS
NEW YORK

IMAN

Contents

L-488441

Iman (Opposite)
Our Hero At Work
Her Majesty Queen Elizabeth Jane Bates
Greta Garbo
Her Imperial Majesty the Shahbanou Farah Pahlavı of Iran Lesley Blanch
Kathleen Ferrier John Amis
St Lucian Woman of 104 years Derek Walcott
Angela Rippon Eric Morecambe
An Old Woman in Bath Val Hennessy
Judi Bowker Byron Rogers
Rebecca Fraser
Motorcycle
Bianca Jagger Roderick Gilchrist
St Lucian Mother and Child Alan Ross
Madonna Edna O'Brien
Axelle Doué
Miss Piggy Kermit
Dorothy Parker Whistling Girl by Dorothy Parker
Princess Caroline of Monaco Olivier Echaudemaison
Edna O'Brien Herself
Elizabeth Taylor Hugh Wheeler
Elaine Paige Tim Rice
Indian Mother and Child James Cameron
Marlene Dietrich Willi Frischauer
Lesley-Anne Down David Frost
Stella McCartney Paul McCartney
Blue Fields River, Jamaica
Madame Grès François-Marie Banier
Rose Kennedy Lord Longford
Her Majesty Queen Elizabeth The Queen Mother Hardy Amies
Ingrid Boulting David Bailey
Dame Sybil Thorndike Sir Cecil Beaton
The Hon. Vita Sackville-West James Lees-Milne
Miss Pearl
Lady Helen Windsor
Twiggy Michael Parkinson
Promenade
H.R.H. The Princess Anne Jeffrey Bernard
Alice Longworth
Zandra Rhodes Russell Harty
Mrs Lyndon Baines Johnson Douglass Cater
Princess Dina Abdel Hamid Alastair Duncan
After Kees Van Dongen
Beverly Manley Barbara Gloudon
Baroness Masham of Ilton,
 Countess of Swinton Lord Crawshaw
Diana Vreeland Norman Parkinson
Vicomtesse Jacqueline de Ribes
Marisa Berenson
My First Nude
Ava Gardner Jack Cardiff
Mary Ann Slinger in Trinidad
Madame Simone Weill Sam White
Carmel Strelein
Erin Pizzey David Astor
Wenda Parkinson Quentin Crewe
Elisabeth Frink Laurie Lee
Kate Fitzpatrick Patrick White
Mustique
Mamie Eisenhower Robert B. Anderson
Sophia Loren Barry Norman
Dame Edith Evans Christopher Fry, Oliver Messel
Girl in Bikini Aldwyn Roberts (Lord Kitchener)
H.R.H. The Princess Margaret Nigel Dempster
Barbara Cartland Herself
Vanessa Redgrave Naim Attallah
Tracy Ward
Vivien Leigh Quote from Shakespeare
Mrs Boehm M. de Min, Manager Le Grand Hotel, Rome
Bird Island, Seychelles
No. 13 Cemetery Road, Marie Galante, Petites Antilles
Acknowledgements

Copyright © 1978 by Quartet Books Limited

All rights reserved. For information, write:
St. Martin's Press, Inc., 175 Fifth Ave.,
New York, N.Y. 10010

First published in the United States
of America in 1979

Library of Congress Catalog Card Number: 78-66164

ISBN: 0-312-72746-1

Photographs copyright © Norman Parkinson

The Whistling Girl' by Dorothy Parker, from The Portable
Dorothy Parker copyright 1928,©1956 by Dorothy
Parker, reprinted by permission of the Viking Press,
New York, and Duckworth, London (The Collected
Dorothy Parker, 1973)

All other texts, copyright © by the individual contributors

Printed in Italy by Mondadori, Verona.

Our hero at work

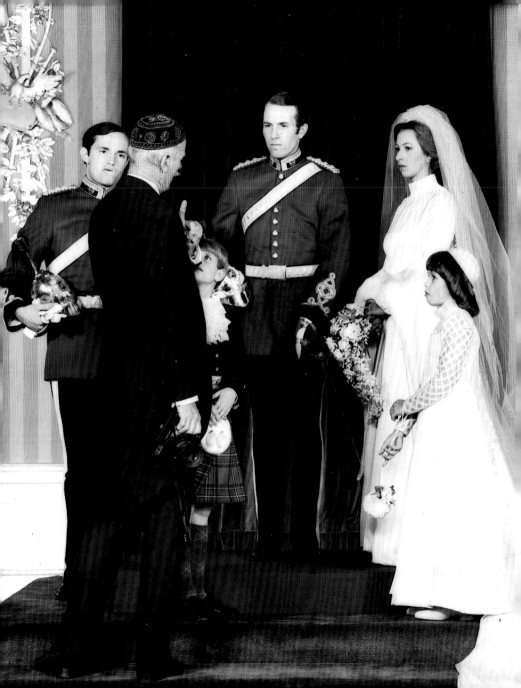

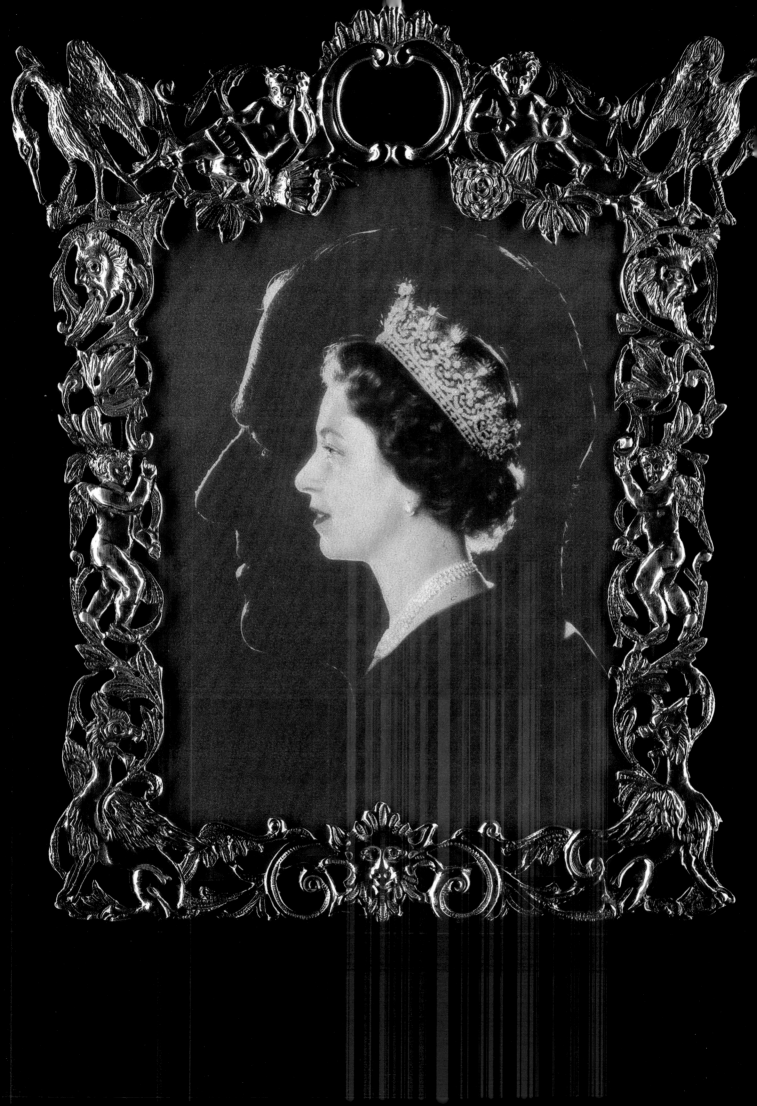

The Queen has a hard busy day. She signs document and holds meetings. I should think she finds life hard and boring. She watches the clock ticking all day, waiting to relax, to take her dogs for a walk and talk to her children.

She goes on her balcony to get some fresh air, but she may forget that there are people out there, shouting for her. She signs and sinks into a chair. She thinks about all the things she has got the next day, Princess Ann will be coming.

Supper comes, she pushes it away She's got a headache. She needs a disprin. The Queen slowly gets undressed and falls asleep.

by Jane Bates

(aged 10)

GARBO !

GARBO !!　　　GARBO !!!

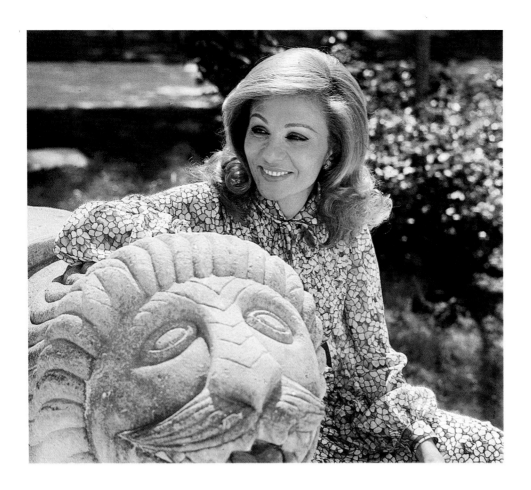

HER IMPERIAL MAJESTY THE SHAHBANOU FARAH PAHLAVI OF IRAN

Lesley Blanch

Charm has been defined as the bloom on a woman; here is the most charming of women, and one of the most outstanding in today's troubled world. Her fabled beauty, elegance, and glowing warmth are apt to blind the beholder to her force of character, intellectual qualities, and the ardent idealism and practical sense with which she has met the challenge of her extraordinary destiny. The Cinderella syndrome so beloved of the press is quite untrue, her background being country gentry, her father an army officer, the milieu cultivated, liberal, of small means, but the loftiest ancestry in all Islam, since through her father the Shahbanou is Seyyed–a descendant of the Prophet. Nevertheless, it might have been overwhelming for the young, shy architectural student of 1959 to be chosen by His Imperial Majesty the Shahanshah Mohammed Reza Pahlavi, to share with him the glories and responsibilities of the Peacock Throne. Not so. She has set a new dynamic pattern or pace for Royal ladies, as her helicopter (transformed into a working bureau) whisks her high and low to achieve, often by unconventional methods, the limitless problems she tackles.

Iran was civilized before Greece or Rome, and long known for its beauty as the Turquoise Kingdom: today as an oil well for the world. Such contrasts stimulate. The Shahbanou Farah, who is adored throughout Iran for her beauty and bounty, is also known as the Working Empress, a title she cherishes. She does not dawdle over the glittering trimmings of her rank. The arts, music, ski-ing, those are her relaxations; solitude her rare luxury. Travelling libraries and sports facilities for remote areas, museums, new concepts of architecture, the loving restoration of old buildings, green spaces for greying cities, judicial reform concerning the rights of women and children, the revival of traditional crafts – these are some of her preoccupations. Above all she has become a symbol for Moslem women everywhere.

When, at his Coronation, the Shahanshah also crowned her, she became the only woman to be so elevated in the history of Iran, or in the tradition of Moslem lands, where women mostly have remained shadowy figures. Moreover, the Shah invested her with Regent's powers should the need arise before the majority of their son, the Crown Prince. Thus he stressed not only his nation's trust in her, but the ever-growing responsibilities which, today, women everywhere must assume, and which she has met so triumphantly.

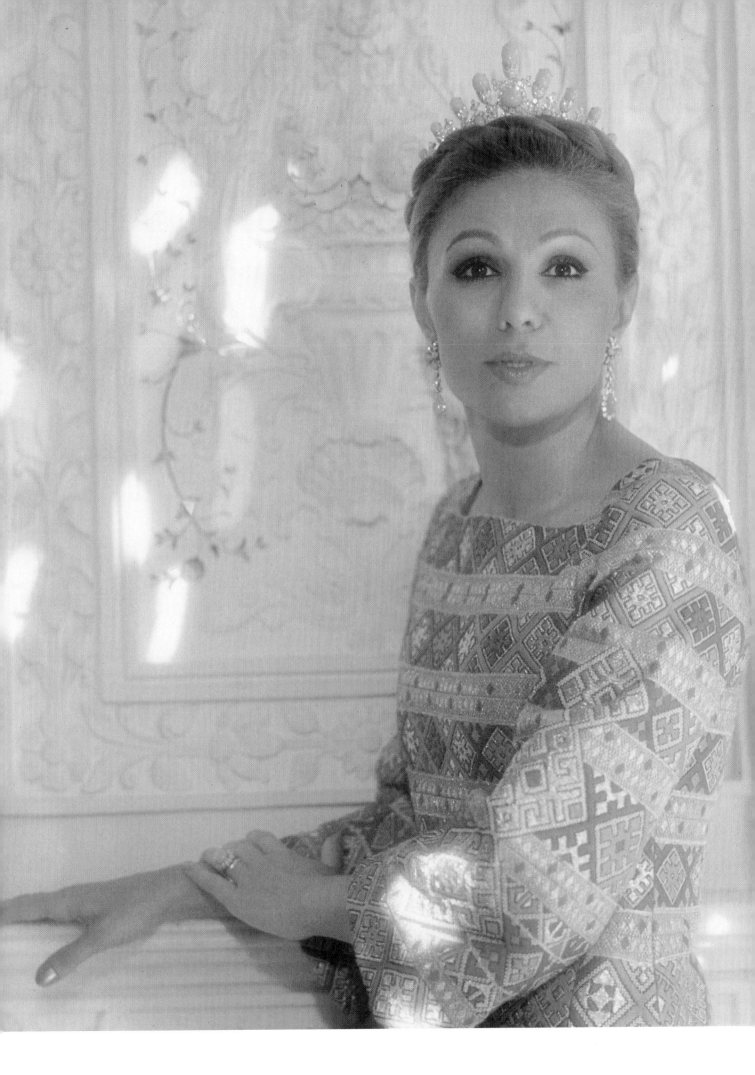

KATHLEEN FERRIER

John Amis

Early photographs show a rather plain girl, just another pianist from 'oop North'. She turned to singing quite by chance and, in fulfilling herself, she blossomed into a beauty; she became the most famous contralto of the post-Second World War period. In little more than a decade she was a world star; then cancer killed her at forty-one in 1953.

'Oop North' was Lancashire. Her father was a village schoolmaster so her background wasn't clogs and shawls – like Gracie Fields – but neither was it 'bay windows and posh'. Kath, or Kaff, as she called herself, started her working life as a telephonist; she won prizes in competitions, even broadcast as a solo pianist and accompanist. One day she thought that she could sing as well as some of the competitors so, for a bet, she 'went oop and 'ad a go' and won the Rose Bowl, top prize at Carlisle. Came 'South', first London recital 1942, still gauche but learned well and quickly, got on to the 'Messiah' circuit; probably more people heard her in the flesh sing in Handel than anything else.

Gluck's opera 'Orfeo' was a natural for her – her simplicity, nobility, radiance and musicianship won the day for her on the stage at Glyndebourne in 1947, as they had when she created the title-role in Britten's 'The Rape of Lucretia' the previous year. With Bruno Walter she studied Mahler; with Barbirolli, Chausson, and Elgar's 'Gerontius'. In all this music Kathleen Ferrier was incomparable, just as she was in Brahms's 'Four Serious Songs'. But she could also move you to tears with a folksong like 'Blow the wind southerly', singing it as unaffectedly as a woman outside a cottage in the dales.

The voice was a genuine contralto, a deep voice that is rather rare today – and rare any day without the hoot or baritonal honk that beset, for instance, Clara Butt. Some think of Janet Baker as Ferrier's successor, but Dame Janet is a mezzo-soprano, whereas Kath's voice was pitched four or five tones lower. But, though deep, there was nothing manly about Kath's voice; it was velvety, 'ewige Weibliche', 'eternally feminine', rather than sexy. We Brits find it hard to give our whole souls as musical performers; but Kath could do it – she loved to give music. She could communicate so universally that the audience was in the palm of her hand the moment she even came on to the platform. This is not just gush: unsentimental musicians like Benjamin Britten and Gerald Moore have said it too.

Off-stage, Kath was a mixture of simplicity, dignity and fun; like many serious people she had a penchant for colourful swearing that was very funny and quite innocent. She tried marriage early on but it fizzled out, 'dissolved'.

Going in tears to her dressing-room after 'Orfeo', she would ask: 'Was it all right, luv?' Going in trepidation to the hospital during her last illness, wondering how on earth to cheer her up, we found the boot was on the other foot: she cheered us up. How was she feeling? 'Oh, don't let's talk about that subject, it's too boring, I'm all right.' So we talked on and came away refreshed by her spirit.

Kath's final years, and after, brought a certain over-reverential reaction, but we've got over that now. For something near the truth about Ferrier, listen to her records; they're not all good, but in the composers mentioned above she excels: the voice was the person, she became the music she sang. Kath's voice was a 'short' one, and it is the tension in the top notes that makes it so poignant and beautiful. But the voice wouldn't be beautiful without the technique, control, thought and character behind it.

It was a short life, too, but everything combined in those last ten years to make Kathleen Ferrier a unique and truly great musician.

POEM

Derek Walcott

It hovers on extinction
like a diamond
at the dim end of a mine,
like the last coal
in an old coalpot,
the light
kept alive
by the sea-wind that fans her
from the beach of Gros inlet.

The wind that goes
through her body's crevices,
like the fishermen's huts,
that swings the hinges of
 creaking elbows of an old gate,
that is laden with the smell
 of the coalbasket she carried,
weighing one hundredweight
on the slender black pipe
of that iron neck,
without touching the basket
along the steep
white cliff of the coalship
 of Castries harbour.

Whatever she has been
age is not a triumph.
The light of astonishment
is in the eye of the beholder.
There is no defiance in numbers.
Trees have died before—
 that gives her no pride
any more than the memory
of her rope-sinewed stride.

There are certain companions
that such long age earns:
the casual conversations
with elemental things
that were called gods once
when once we had souls.
The wind sings
for her, the sea
at dusks brings her its gossip.
Her gaze exchanges
fire for fire
with diamonds, with coals.

ANGELA RIPPON
Eric Morecambe

I'm so glad that Norman Parkinson has asked me
to write about my favourite dancer Angela Rippon.
After all, I owe Parky a favour or two, he's used me
on his television show a couple of times. Do you
know, I never realized that he was such an
excellent photographer?

As for his portrait of Angela, what can I say? What
CAN I say? It's perfection, and as for Angela, I admire
everything she does; her dancing, her
horsemanship (or should it be horsepersonship?)
and her skill with a rifle.

What do you think of it so far? You do? Well, that's
a pity because there's more to come.

Of course, I always thought that Angela would be
a great asset to the diplomatic service. Still, they've
got Geoffrey Rippon, and although he's very good
at his job, I'd rather see Angela at the end of a
chorus line than Geoffrey. Anyway, Angela has
enough to do with her career and being married to
Mr Dare of Plymouth. Hoe! Hoe!

Seriously, I am delighted to have been asked to
pen this tribute to one of my favourite ladies.
With all her multi-talents she ought to be seen
much more by the viewing public.
Surely there must be a job for her somewhere?

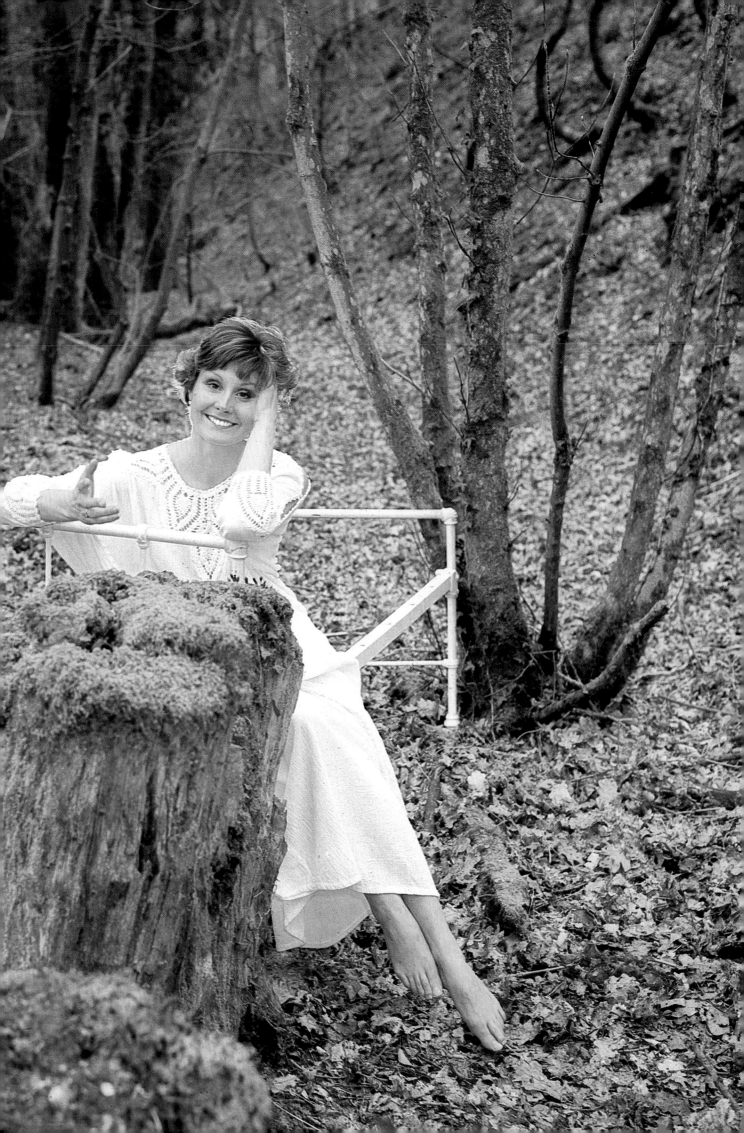

'With the ancient is wisdom; and in length of days understanding' – Book of Job 12 : 12.

On a lichen-smothered tombstone in the loveliest churchyard in England at St Just-in-Roseland in Cornwall is this epitaph:

> There is great beauty in old trees
> Old streets and ruins old
> Why should not I as well as these
> Grow lovely growing old?

The serene and authoritative old woman of Bath possesses the air of intrinsic vitality and wisdom which only comes from long perspective. If we hurry past her on the pavement, there will exude from her elegant person the musty odour of forgotten photograph albums and a faint perfume of lavender. She finds it incomprehensible that the Western world should so overvalue youthfulness; that it should consider the first grey hairs as 'death's blossoms' or as harbingers of decay. She scorns her blue-rinsed contemporaries with their fluorescent-shadow spread upon ravaged eyelids and with rouge plastered upon their tired lips; those obscene, frolicking grannies clinging with despair to their extinguished youth.

With fragile hands the old woman of Bath proudly brushes her exquisite white hair, untarnished by tinting, undamaged by perms. She coils it meticulously with fastidious elegance into a chignon arranged beneath her essential hat. Look hard at the shabby gentility of her Edwardian lace collar, her gloves and her bag. Then observe her feet, once nimble, now numbed with arthritis. Feet which long ago ran across meadows and waltzed with lovers. For appearance's sake, she defiantly crushes her swollen left foot into a battered fashion-shoe. Imagine the indignity, the admission of defeat, when she finally gave in to the pain and first went walking with that right foot ignobly clad in a scruffy carpet-slipper.

From her tantalizing back view, we can guess that her complexion is pale and powdered, her mouth tremulous and the expression in her eyes fiercely independent. With a great sense of calm and dignity, she is determinedly avoiding the treatment meted out to unwanted old ladies by our society, which labels them 'geriatric' and abandons them to pine like lonely old dogs in gloomy rooms. She is beautiful in her dilapidation.

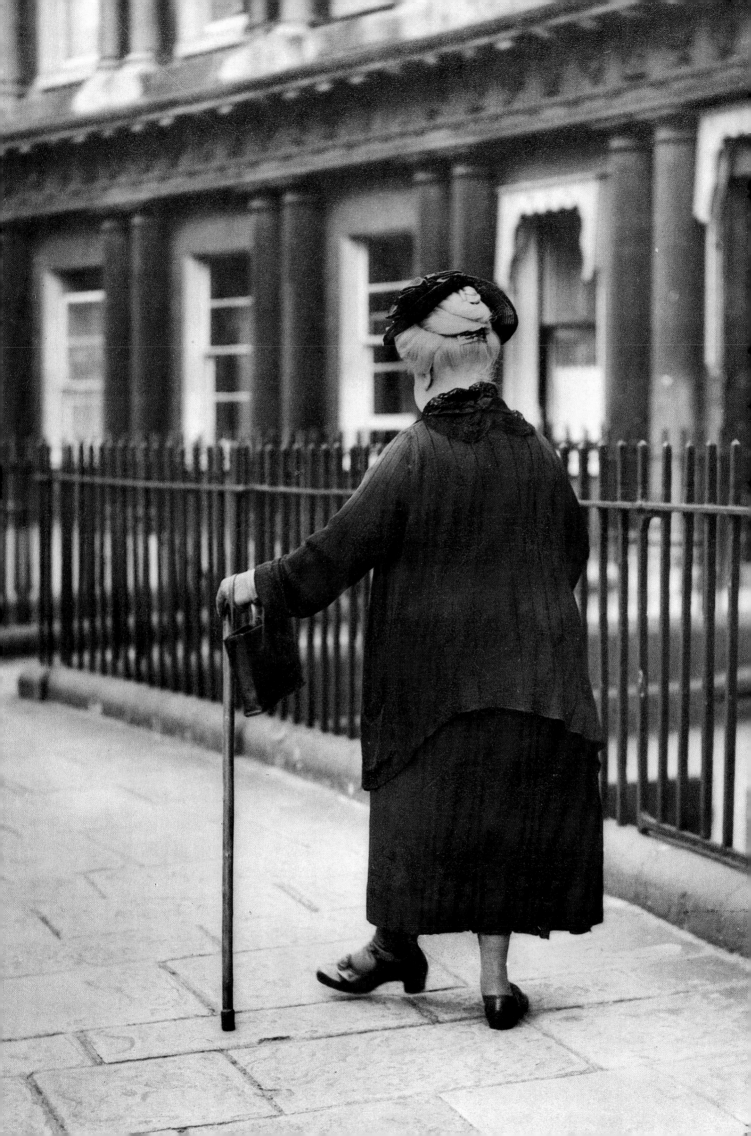

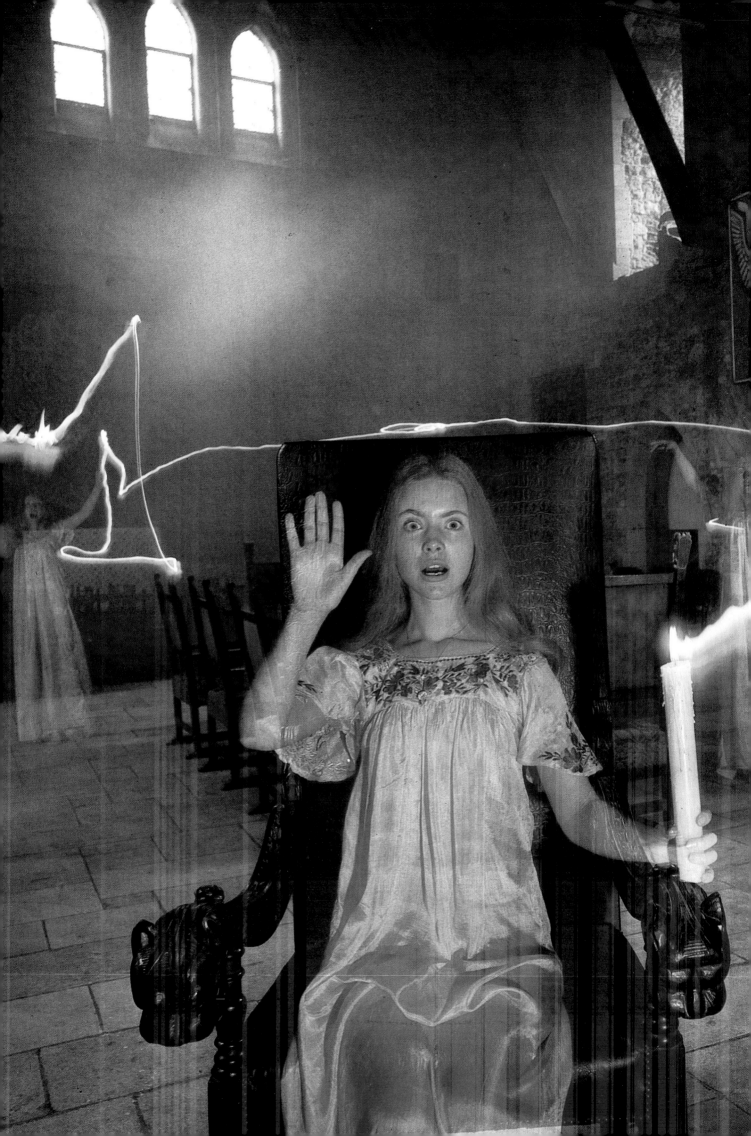

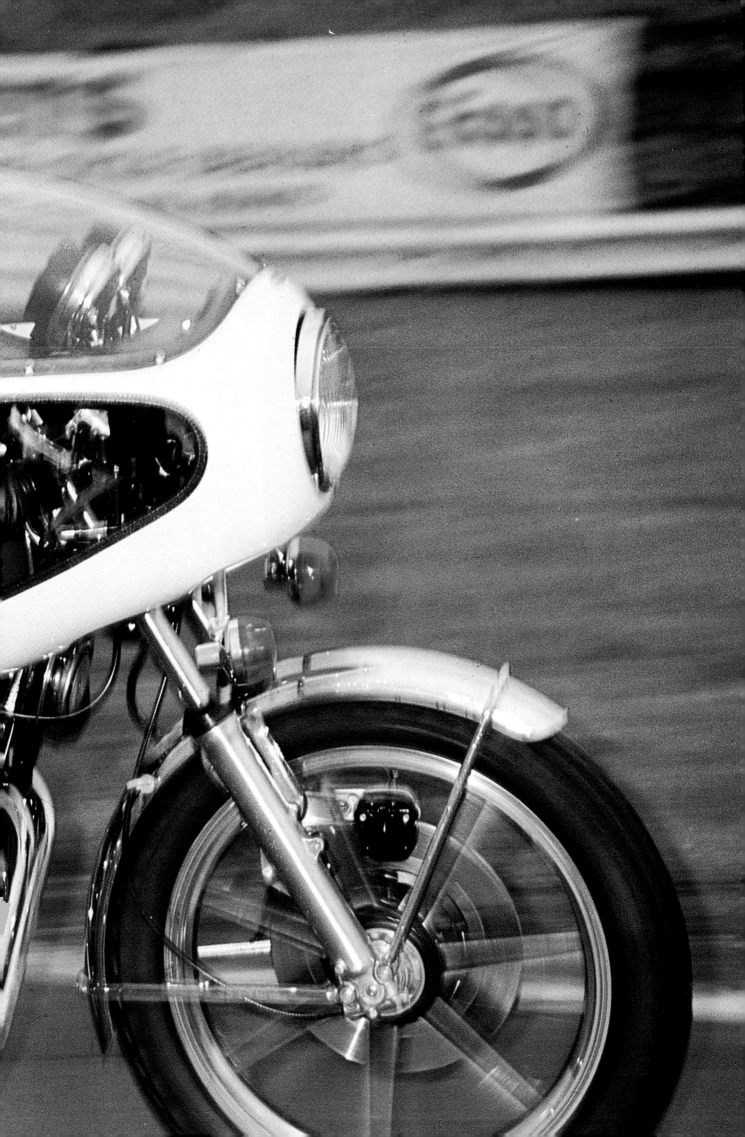

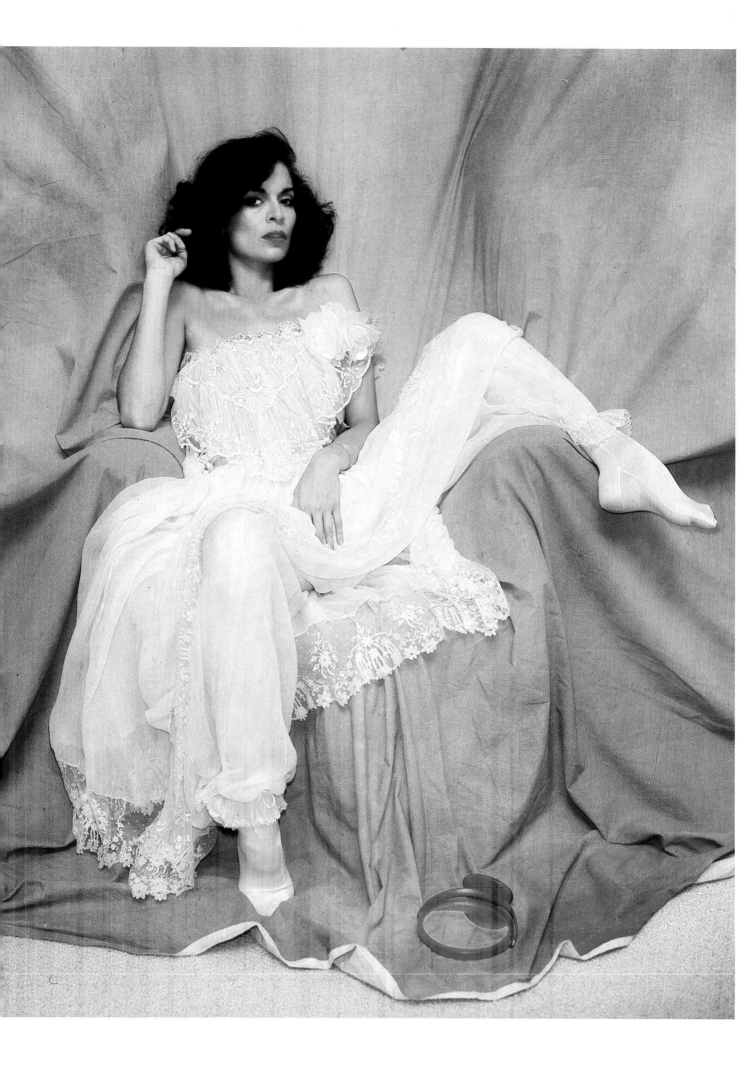

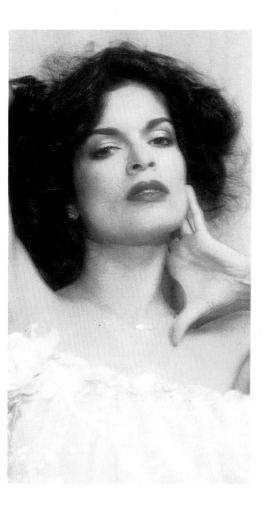

BIANCA JAGGER
Roderick Gilchrist

The music from the black velvet abyss where super rich men with cocaine eyes dance opposite languid ladies who affect a bored chic says 'Isn't she lovely, isn't she wonderful?' and Bianca Jagger lets the beat ripple through New York's Studio 54 before she allows her hips to sway in time, as if she is a human metronome. All around there are photographers, their Nikon bulbs exploding like artillery flashes in the dark, and in the newspapers the next day there will be headlines above the pictures that say the 'Bianca Boogie'.

The attention, while often unwelcomed and usually misleading – for there is a danger that her dramatic profile and reputation as a fabled queen of the night can lead to a frivolous press not always helpful to her new career as a serious actress – is nevertheless understandable.

To millions of women throughout the world, to shop girls and secretaries, to titled ladies, models and movie stars, the seemingly glossy life of the former Bianca Rosa Perez Macias is the single central reference point in contemporary society for style and elan. A flesh and blood Vogue. Diana Vreeland's immaculate conception.

It is not just her striking physical persona; the hair Guinness-black and lustrous, the eyes a liquid hazel, the shoulders and legs gamin and elfish, that fascinate. Nicaragua's most famous daughter displays an insouciant sense of high chic that appears so recklessly effortless it invokes both envy and frustration in those who seek to imitate her. Accurately capturing Bianca's tangible personality, as opposed to her newspaper profile, is considerably more elusive.

Sometimes, though, the armour can be pierced. She reveals intriguingly it is the tragic Zelda Fitzgerald, the flawed romantic who, as Ms Jagger analyses it, 'Died in the flames' that she feels a strong sense of identification with.

It seems a contradiction, for the face that Bianca presents is that of a confident young woman secure in the knowledge that she is revered as one of the twentieth century's most distinguished beauties.
Bianca explains: 'Zelda was a schizophrenic. Sometimes I feel my life is two sided. There is one side that makes me a perfectionist – there is the other side that wants to go out and dance and be young and silly. Zelda gave it all away. That is like me but maybe I will go beyond Zelda and escape the flames.'

There is a mystery about the sentiment that Bianca does not care to explain, but an enigma, as Garbo has demonstrated, provides constant intrigue. Curiously for one so admired she is in perennial need of reassurance that she is beautiful and intelligent and cherished. For such a worldly woman, who, it must be said, is great company there is an endearing but strangely juvenile uncertainty about her own worth. It is undoubtedly rooted in childhood. Her parents divorced before she reached her teens.

She reaches back to her adolescence when you ask her if she likes men 'No I like little boys,' she says in that sultry voice which evokes images of South American rain forests and exotic people, 'because I am a little girl. I think maybe I grew up too fast. When that happens you are always trying to recapture your youth so you are forever a child.'

Yes there are times when even this reluctant merchant of dreams feels alone and then she leans on an unusual staff. At her home in Chelsea is a large and beautiful fireplace. She likes to stand by it and look into the fire and that, more than anything, she says gives her a sense of calm and place. It conjures a compelling vulnerable vision, and one that sits uneasily beside the Bianca of Manhattan disco nights.

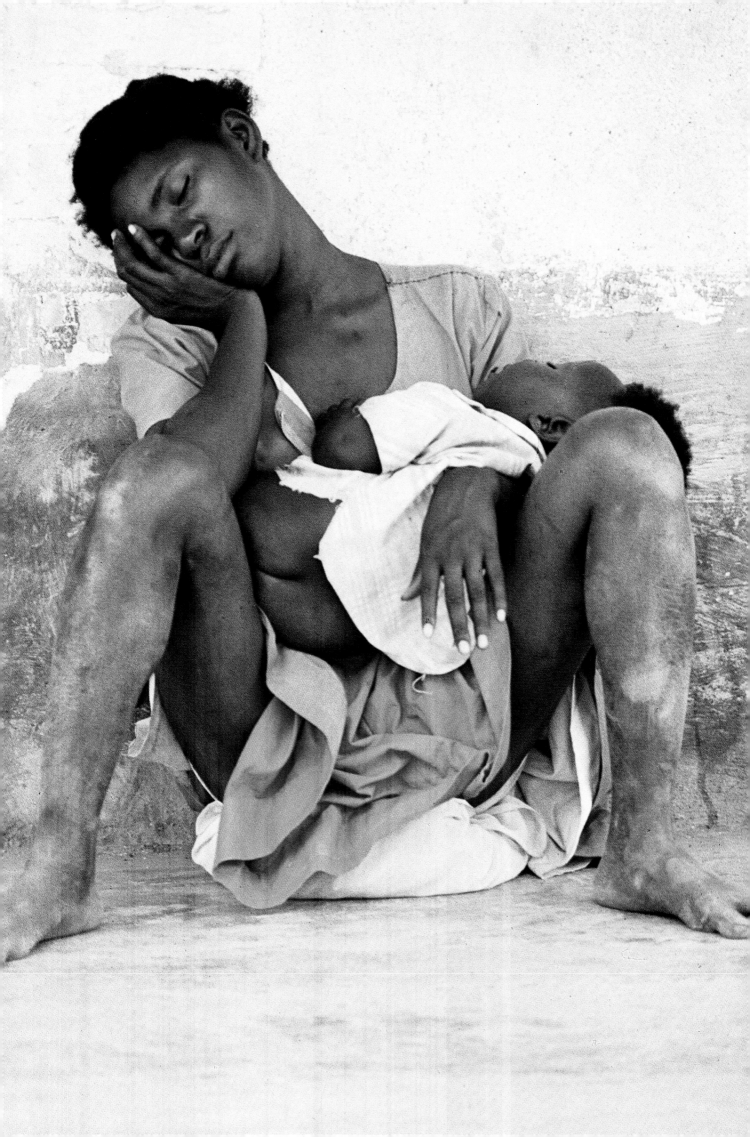

ST LUCIAN MOTHER AND CHILD
Alan Ross

The fatigue of bliss, or the bliss of fatigue?
Opened up to sunlight, straddling the roadside for a striped banana-bus (buses that bear propitiatory names 'Forever My Love', 'Patience', 'All Over'), the road winding between Choiseul, Souffrière, Vieux Fort, is it from the burdens of the night or from race-memories of Africa that she seeks escape? She, who under the umbrella of an immortelle, among the mangoes and the breadfruit, to herself has taken 'sea-music and sea-light'.

When flesh upon flesh was the tune
Since the first cloud raise up to disclose
The breast of the naked moon.

If St Lucia is not the most beautiful of West Indian islands, its poet, Derek Walcott, has made it seem so. Blue harbours of Marigot and Anse de Sables, the soft mauve wool of the Pitons, sickles of white sand. The mountains bear vegetation as crinkly and close-cropped as the skulls of Negroes. The cricket field is cut out like a cockpit high in the woods above Castries.
And along all the roads women such as this waiting or walking, invisible at night except for their clothes, caught in the sharp glare of headlamps. A beautiful lilting patois, West Indianized French, but their language is of the hips, swaying, used to carrying children, pitchers on their heads, laughing. In such lushness of surrounding, poverty becomes picturesque, an extension of landscape: coral, bamboo, fern.
Like their men they seem almost boneless, filleted. Heads loll, arms sprawl. They are creatures of slump, awaiting the call to dance. They bear the weight of the sun, of a long past. In their grace there are intimations of shackles, their eyes look longingly across oceans.

MADONNA

Edna O'Brien

This is a Madonna. Looking at her one also thinks that she might be a child
so minute are her features. Or she might be a goddess since she is flanked
by protective beasts. So she is more than one thing. In mythology it is one god
who makes Achilles promise not to go into battle, and another who urges him
to it and yet another who clothes him in the golden raiment in which he shall
be slain. Our lives and our idols are composed of such inconsistency.

 This figure haunts by reason of its inscrutability. Its effectiveness is that
it is a mystery. It suggests no race, no thrust, no sex, no wrath, no need, no pity,
no maternity, no milk – a sublime nothingness. Age shall not wither her who
is already half withered. The wood is peeling on the perfect cheekbones and
there is an inference of one taking her mask away. True there is an expanse
of jewellery but that is cultural, perhaps added on, or perhaps a shield. The
eyes are wide open but unrevealing – pools in which one might wander. We
who crave identity, love recognition, and seek relationships would also
welcome her self-containment. We might be freer. Of how many of the
women whose faces adorn these pages will one be able to say, 'I know nothing
about her except that she transmits a strange impersonal courtesy and an
unflinching beauty'?

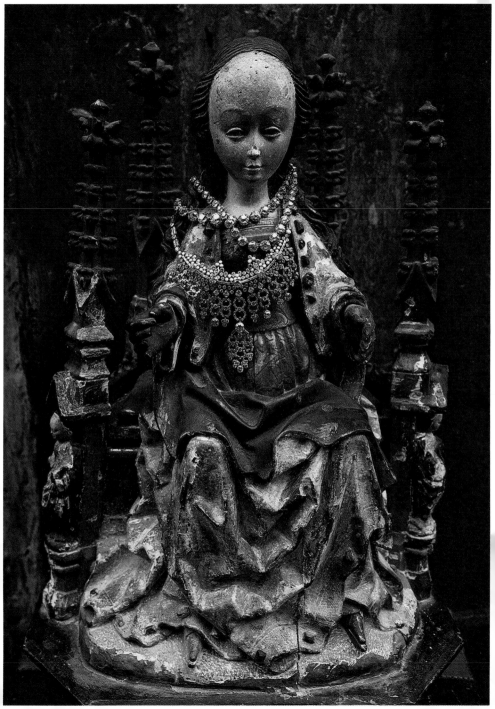

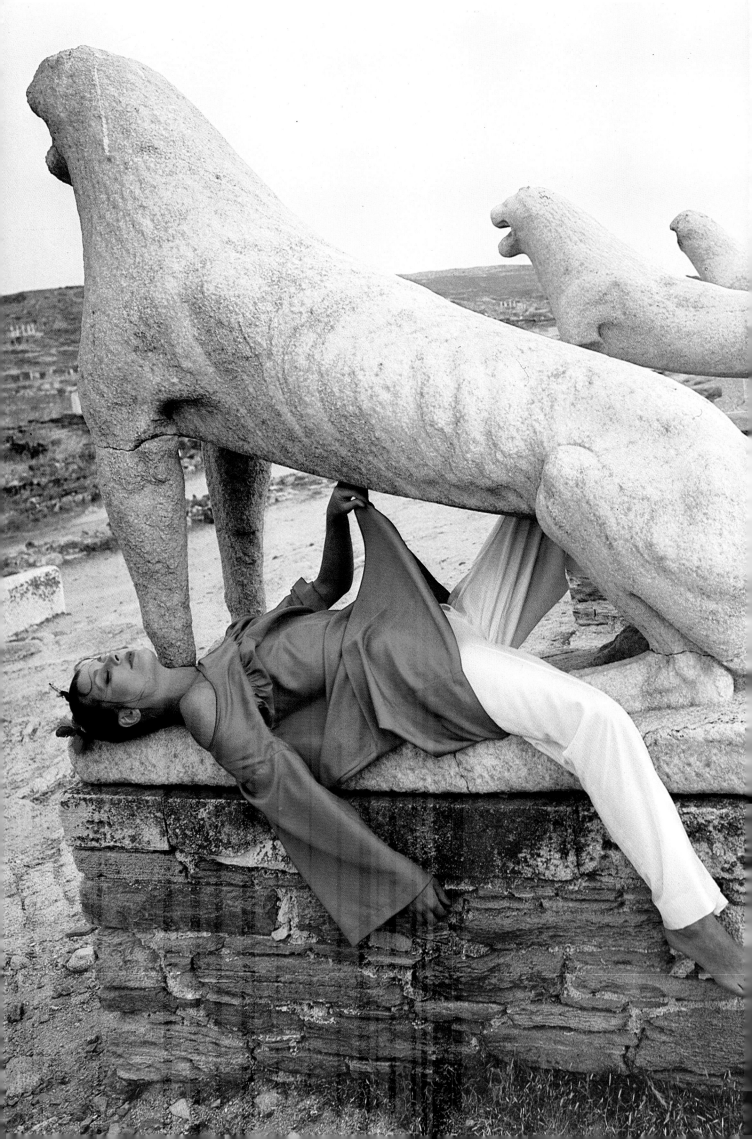

AXELLE DOUÉ, 1977
Delos, birth place of Apollo.

MISS PIGGY
Kermit

I don't know who suggested Miss Piggy should be included in this wonderful volume. I suspect she did. Anyway, I congratulate her: Her appearance between these covers does credit to her initiative, determination and a few other things I don't want to go into right now.

From what I've heard Miss Piggy was her usual uninhibited self when she posed for Norman Parkinson, flinging herself at his feet (I know what it's like – she throws herself at my flippers all the time). In any case, she returned to the theatre, calling him, 'My Parky Baby'. She told me he has invited her to stay with him on his West Indian property, an honour, Piggy says, he has paid no one else pictured in his book. Norman corroborates this unlikely invitation, but assures me his interest in Miss Piggy 'is purely professional'. It is: what he didn't make clear to Piggy is that his West Indian property is a large pig farm.

In conclusion – I would say that Miss Piggy is certainly different from all the other beautiful women in this book. She is an outrageous mixture of sophistication and glamour that culminates in style that is incomparable – which means it can't be compared to anything else. And I have to say that she is absolutely charming, wonderfully talented and stunningly beautiful. I have to say that or she'll chop me in half.

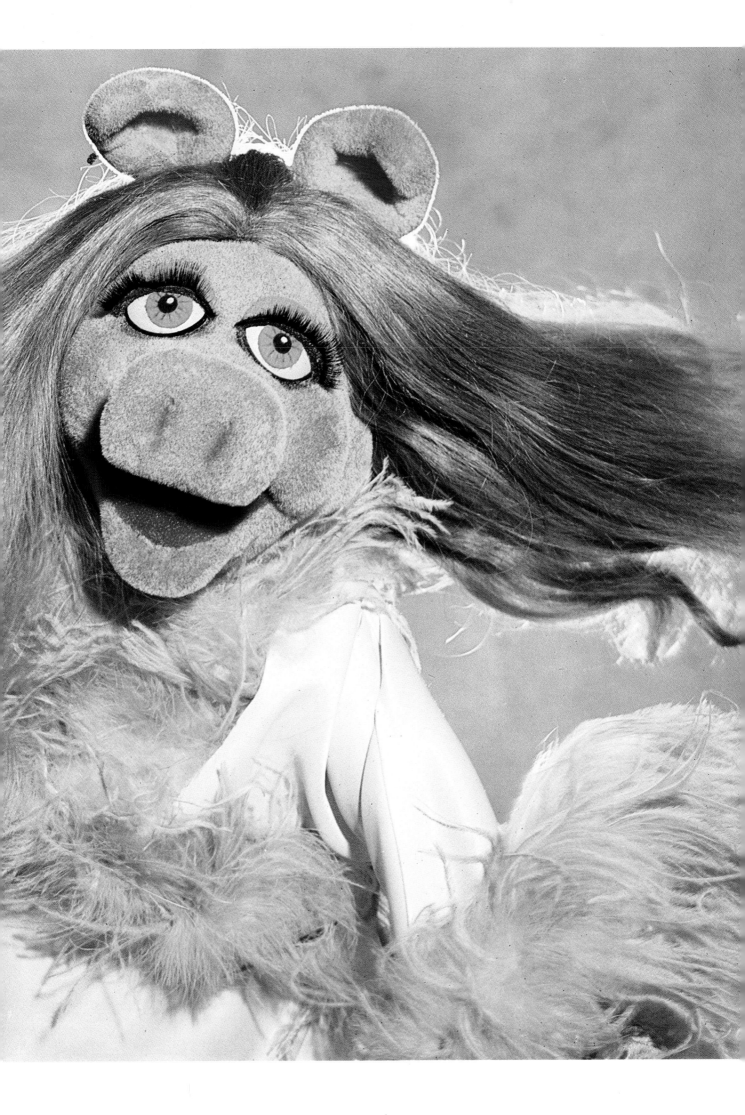

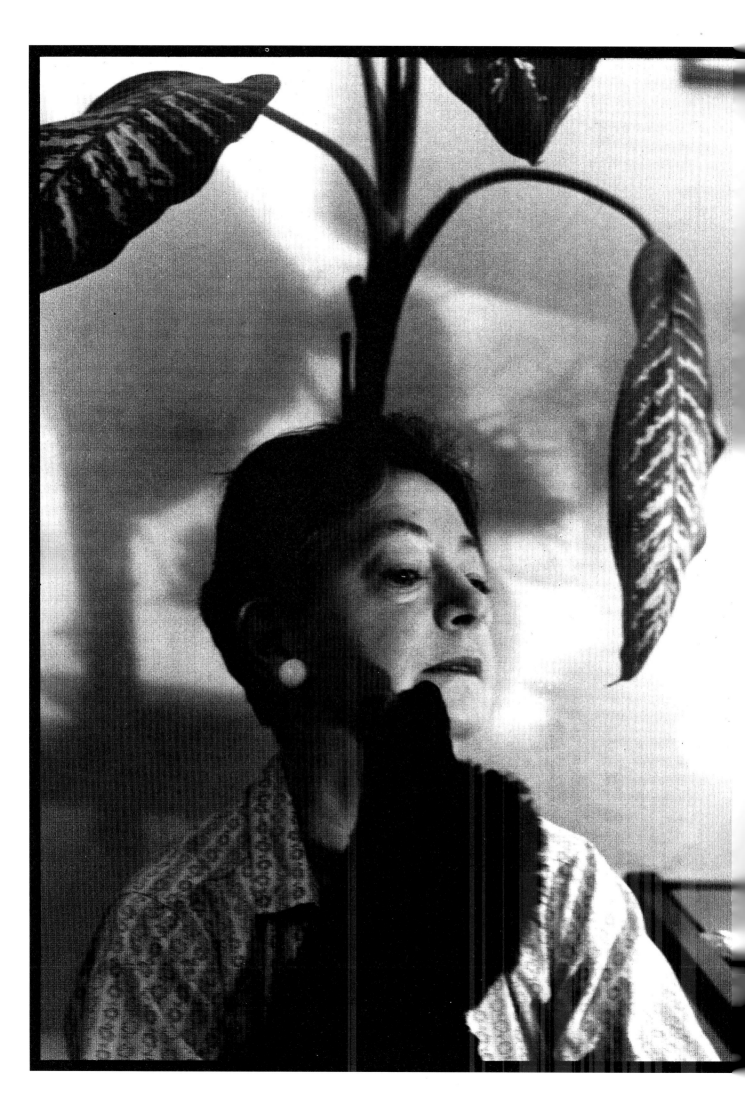

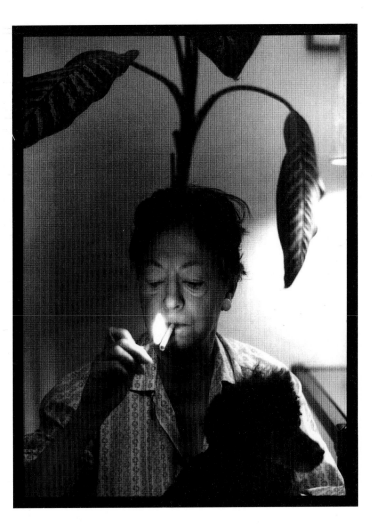

DOROTHY PARKER

The Whistling Girl

Back of my back, they talk of me,
 Gabble and honk and hiss;
Let them batten, and let them be–
 Me, I can sing them this:

'Better to shiver beneath the stars,
 Head on a faithless breast,
Than peer at the night through rusted bars,
 And share an irksome rest.

'Better to see the dawn come up,
 Along of a trifling one,
Than set a steady man's cloth and cup
 And pray the day be done.

'Better be left by twenty dears
 Than lie in a loveless bed;
Better a loaf that's wet with tears
 Than cold, unsalted bread.'

Back of my back, they wag their chins,
 Whinny and bleat and sigh;
But better a heart a-bloom with sins
 Than hearts gone yellow and dry!

'You can take a whore to culture, but
you can't make her think'

'Three highballs, and I think I'm
St Francis of Assisi'

'There was nothing more fun than a
man'

'Four be the things I'd be better without:
love, curiosity, freckles, and doubt'

'I bet you could get into the subway
without using anybody's name'

'If all the young ladies who attended
the Yale promenade dance were laid
end to end, no one would be in the
least surprised'

Dorothy Parker

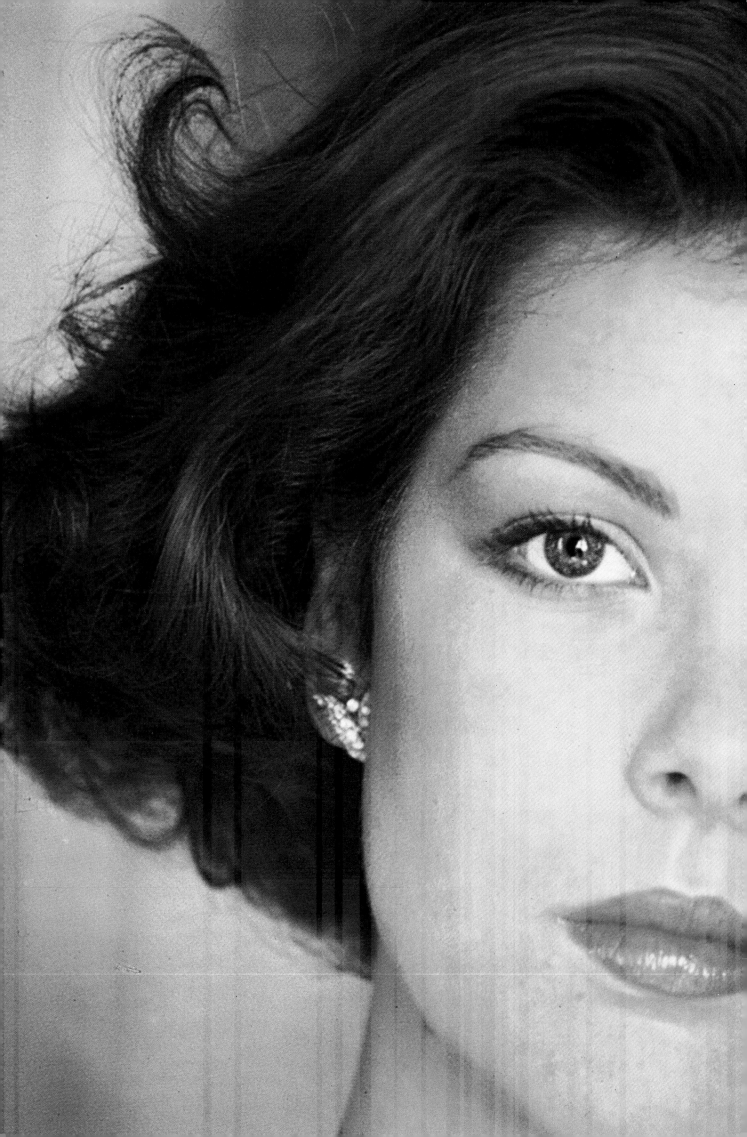

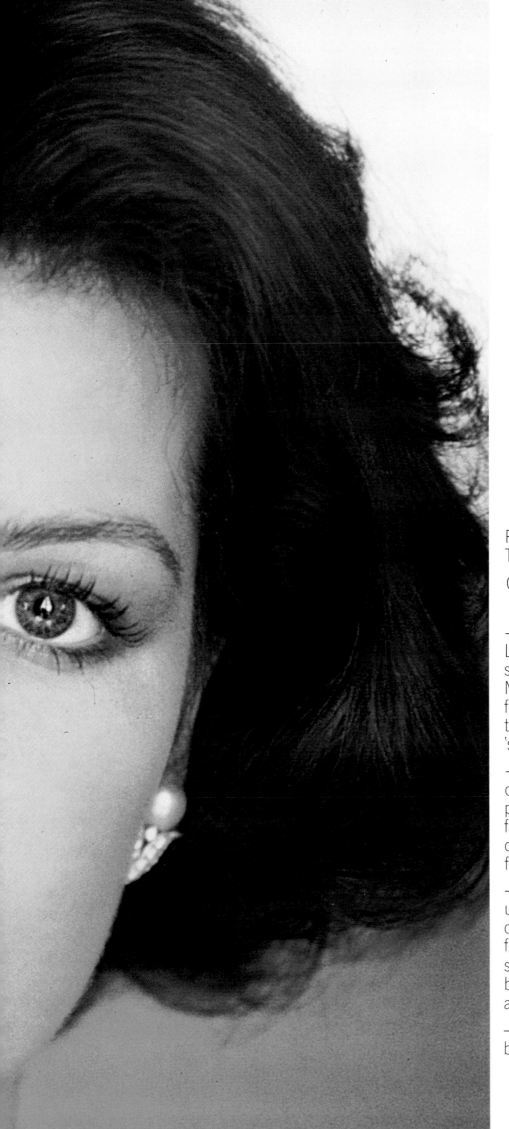

PRINCESS CAROLINE:
THE TWO SIDES OF A MEDAL

Olivier Echaudemaison

– A sexy teenager, dress in Levi's, men shirt, baseball socks, with enamelled Mickey Mouse ear-rings: the best look for a new star in showbiz, close to the everyday reality with 'sparkles laughing'.

– A great Latin beauty: the dream for the fairytales' public, cool and effervescent, family's jewels with chic white débutante dress: a princess for a thrown.

– Who can be both, understands and knows the differents acts of the femininity, be so smart that she succeed what she wants, be the image of the '70s around the world.

– Only Princess Caroline can be.

Edna O'Brien

Snow fell one night
in April
It was just
before the blossom had
come into full bloom
It may have nipped blossom and blood
It was a beautiful snow
But treacherous

When love strikes
it burns crimson things
Yet when the snow fell on my square
I watched the flakes
and the children playing snowballs
suddenly amazed at the perplexity of things

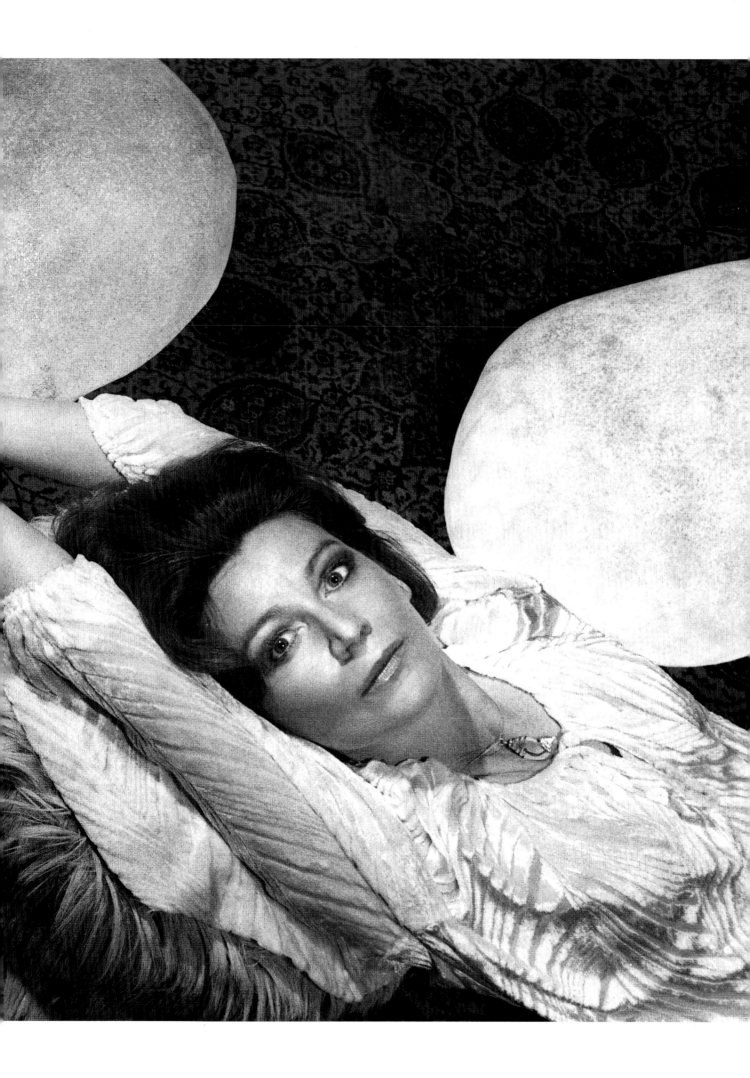

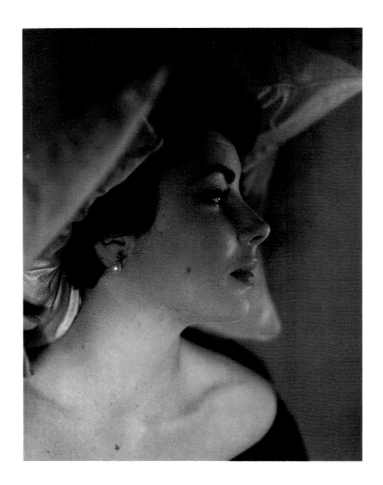

ELIZABETH TAYLOR
Hugh Wheeler

Elizabeth Taylor! What is there left to say? I doubt whether there is an adjective – or noun – in the English language which has not at one time or another been applied to this authentically legendary woman. If there is a footnote to be added at this late stage to all the hoo-hah, perhaps it should point out that, by accepting almost from the cradle that fame was her due, Elizabeth Taylor has never bothered to lift a finger to hold on to it.

Through the years she has blithely remained herself, and that self, described succinctly in a single word, is – fascinating. Then we have to add exasperating, and brilliant, silly, self-indulgent, generous, loyal, vindictive, arrogant, cosy, honey-tongued, foul-mouthed, extravagant, greedy, forgetful, punctilious, lazy, hard-working, warm-hearted, chilly, volcanic, placid, sloppy, immaculate, unforgivable, irresistible.

Okay, let's get it over with. Let's come out and say it for the thousandth time: 'Age cannot wither nor custom stale her infinite...'

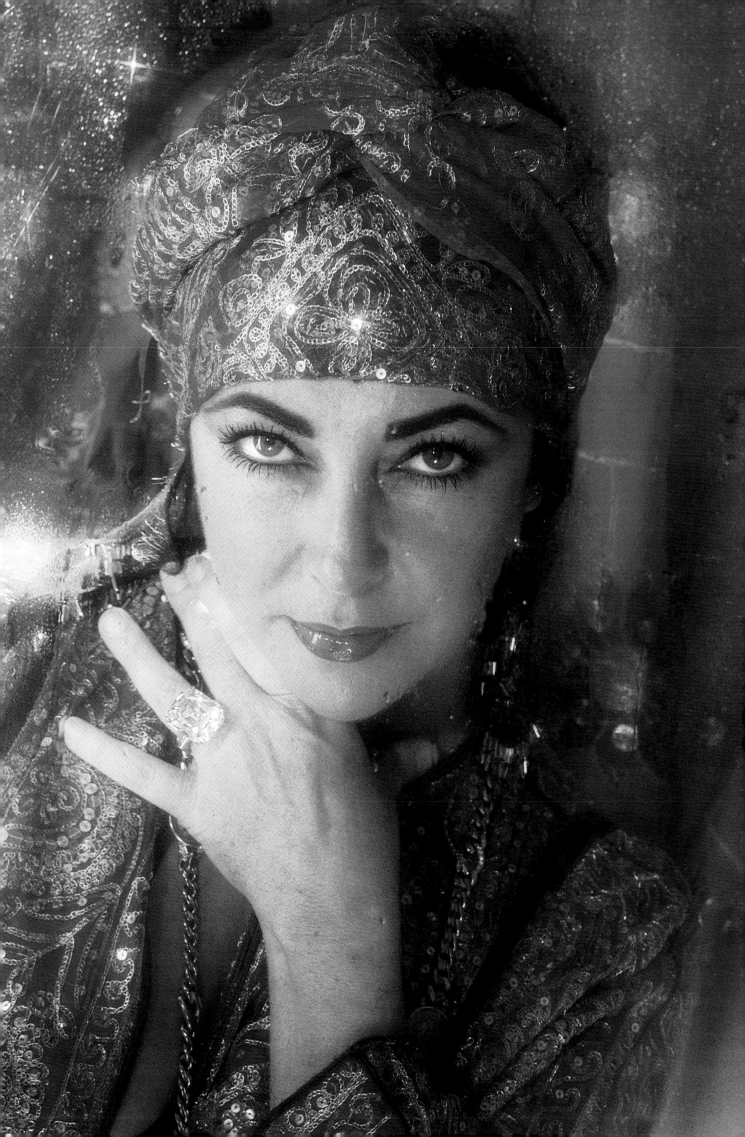

ELAINE PAIGE
Tim Rice

The original record album for 'Evita' was let
loose upon the public many moons before
anyone got round to thinking of it as a stage
show. The unique musical talent of Julie
Covington contributed so much to its
success that her personality seemed
inextricably intertwined with the whole
project.Naturally we (that is, Lloyd Webber
and Rice) were disappointed when Julie
decided that she did not want to do
any more work on 'Evita'.
 During the auditions for the stage
show, spirits sank ever lower, particularly
during some of the less-stunning renditions
of 'Don't cry for me, Argentina'. (If ever we
write another hit song, please let it be only
two minutes long.) Were we going to have
to settle in the end for a second best?
 Then, one morning, the beautiful voice
of Elaine Paige suddenly dispersed the
gloom. There was no doubt about it: here
was a girl who could make the part her
own, and absolutely on her own terms. The
search had not been in vain for our new
 Eva Perón
 – E.P.
 – Elaine Paige!

INDIAN MOTHER WITH CHILD

James Cameron

The pavement is in Bombay, probably, or Calcutta, or anywhere; all places are alike to the street dwellers of the cities of India. The mother shelters the child with her own sari; one piece of cloth must do for two among the poor, just as tomorrow one meal must do for three – or four, or six. The face of India is the face of poverty, counted by the tens of millions, in units exactly like this. For the mother and the child this slice of pavement is not bed, nor resting-place; it is home itself, since there is no other. Not in anywhere else in the world is there anywhere else to go. If you own nothing, you have nothing to lose. When was it ever otherwise? When will it ever be otherwise?

There is the consolation of sleep. Even on the stones of a sidewalk you can share the brief oblivion, for a while. No one will protest, in India; no one will complain; no one will help. No one will even notice. What are two more derelicts in a land of the great anonymous? It is this woman's dharma, her appointed role, to be destitute; she cannot challenge destiny by hope. All she can do is protect the child.

No one knows exactly how many people, individuals, families, sleep permanently on the pavement of India. Who should count them, and to what purpose? Let us say 200,000; it is the customary guess.

So two more nameless statistics seek their little limbo as the passers-by step around them; if you do not look at them, they do not exist.

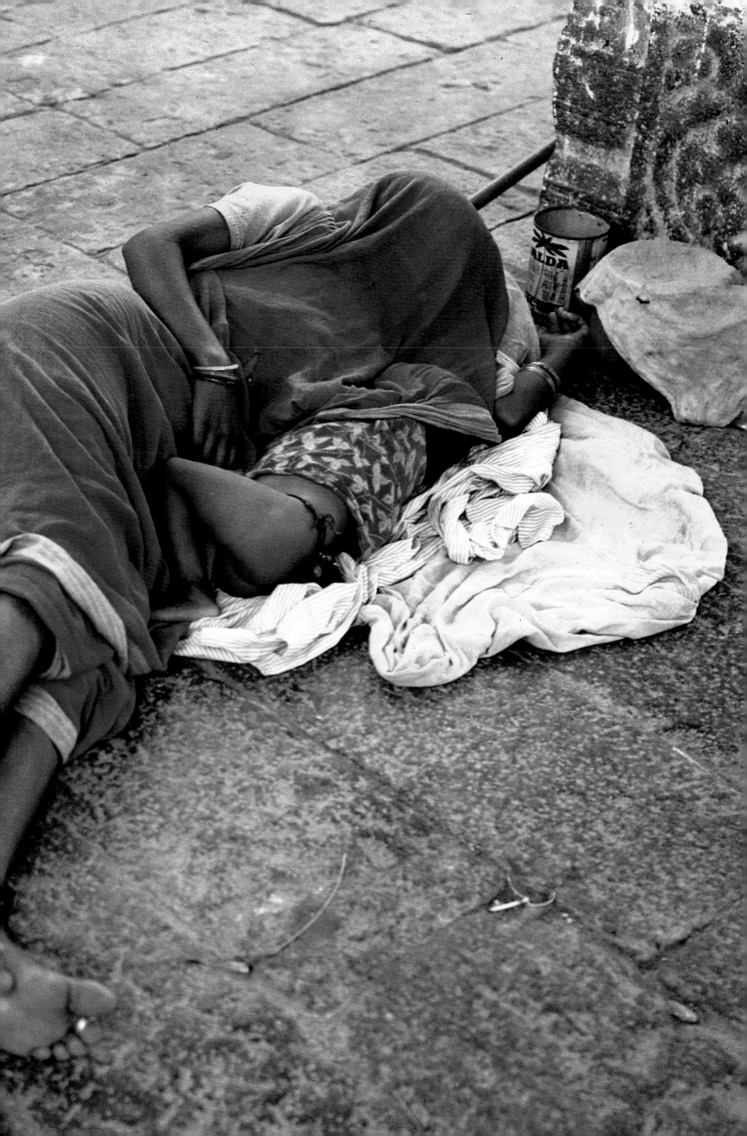

MARLENE DIETRICH
Willi Frischauer

Marlene (here captured in fleeting, characteristically masculine stride) is a delicately robust, beautifully constructed human period piece, a living work of art as valid as a canvas by Van Gogh. The questing eyes, the wide cheekbones with a hint of the Slavonic to soften the sharp Prussian edges, the loose-limbed grace of her big-cat movements recall the doomed 1920s in decadent Berlin when she first flowered like an edelweiss on a compost heap. Passion tinged with fatalism, ice-cold exterior and burning heart – an omelette surprise in reverse – create the mystery which we yearn to penetrate.

Her glamour is undimmed by the patina of the years she has defied with uninhibited individuality. A naughty blue angel in men's trousers (long before women adopted them universally), she enlivened the stage of the Weimar Republic with an act which suggested lesbian inclinations until, prompted by her Svengali – Josef von Sternberg – she could croon with conviction that men buzz around her like moths around the flame.

Immune to the Nazi bacillus, Marlene turned her back on Germany, conquered America and joined the G.I.s who liberated Europe from the evil that had engulfed it in the 1940s, in the process (to quote her) kissing more G.I.s than any other woman alive. In private, as on the screen, she is liable to ask what the boys in the backroom will have and to tell them she's having the same.

Cast as an aloof temptress, she has yet given herself generously in a life dedicated to love, embracing eminent admirers and humble friends, many of whom owe her survival and career. Almost too overwhelming to confine in the straitjacket of literary invention, she has always been best playing herself, poured into a glittering gown like champagne in a tall, narrow glass, her throaty voice exciting and soothing in turn. The first time I met her she was all thighs and sexuality, the last I heard from her was her nostalgic lament for all the flowers that have gone . . .

LESLEY-ANNE DOWN
David Frost

The mid-Atlantic style, like the decisions
of committees, all too often leaves behind
an undistinctive flavour. Everything that is
best in British exports to the United
States, whether films, books, or television
series, has always stayed true to its roots.
From 'The Six Wives of Henry VIII' to Lord
Clark's 'Civilization', and from there indeed
to the American tours of the Beatles or
'Monty Python', the Englishness of the
native product has been uncompromising.
 'Upstairs, Downstairs' came into this
category. So does Lesley-Anne Down. She
fulfils the American dream of the
beautiful, traditional English rose, yet as
an actress has shown herself able to cope
on her own terms with the toughest
commercial demands on her art and
craft.
 And yet, in America, she still
succeeds in being herself. We can still
imagine her fulfilling all the roles
expected of an English gentlewoman:
declaring a church fête open (in a hat,
of course), shopping at Asprey's, dancing
at Annabel's or suing the William Hickey
column.
 Above all she displays that often
baffling and always admirable Anglo-
Saxon combination of strength and
vulnerability. Independent of all the men
in her life, she is voluntarily dependent on
the one man in her life.
 For Lesley-Anne Down, the world is at
her feet. The prospect for her future is
pleasing, if also potentially dizzying. We
can trust her, however, to walk the
tightrope without a tremor or downward
glance.

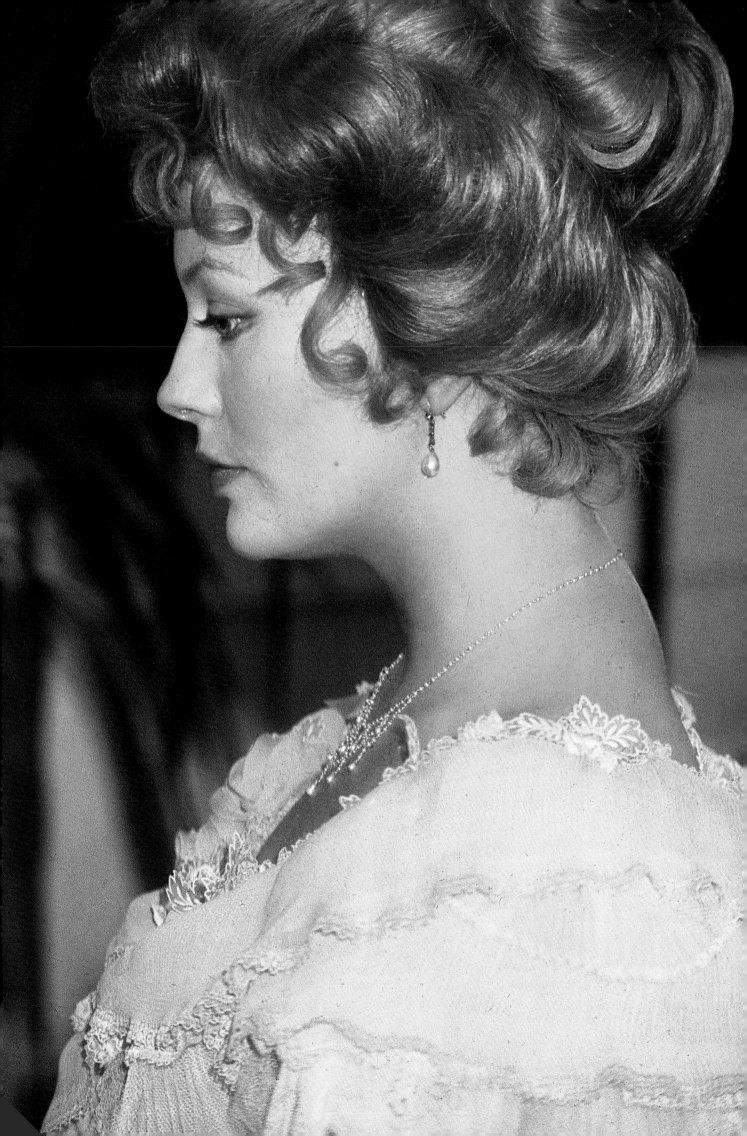

MAMA'S LITTLE GIRL

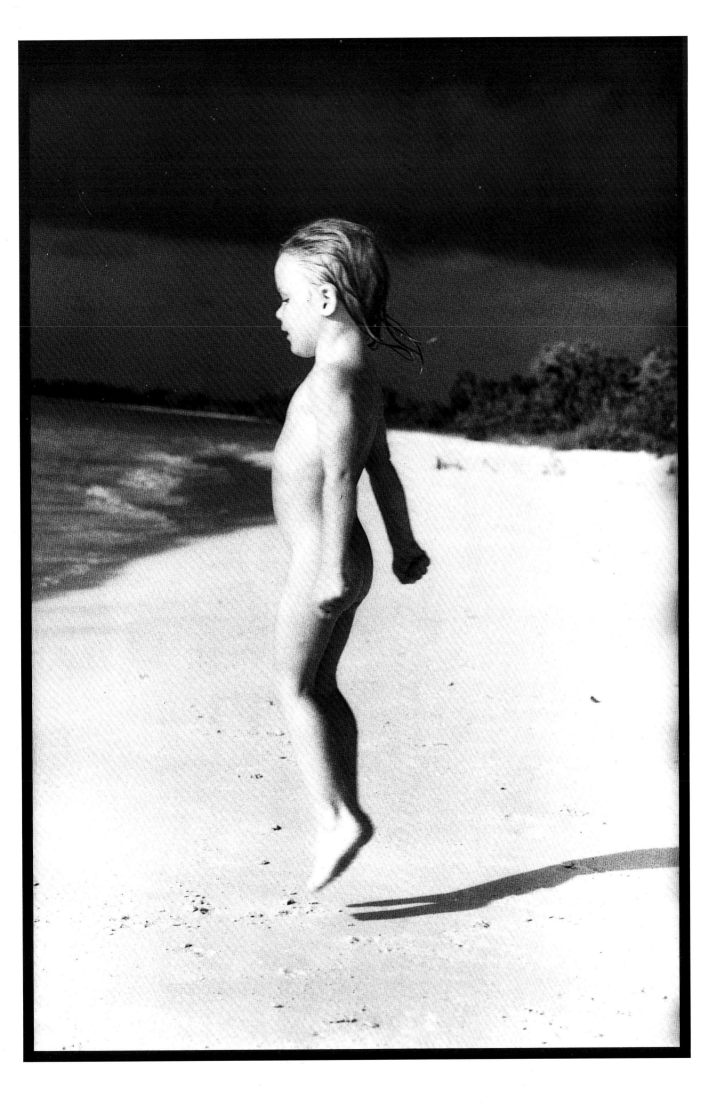

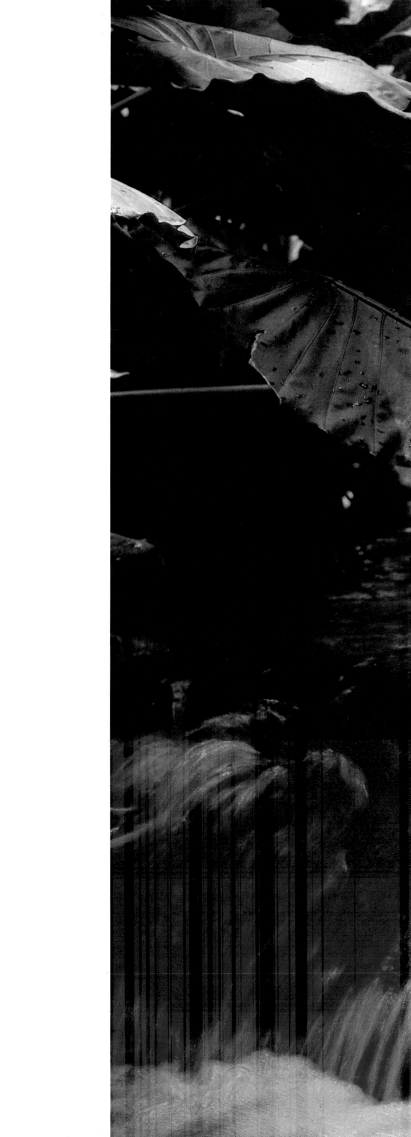

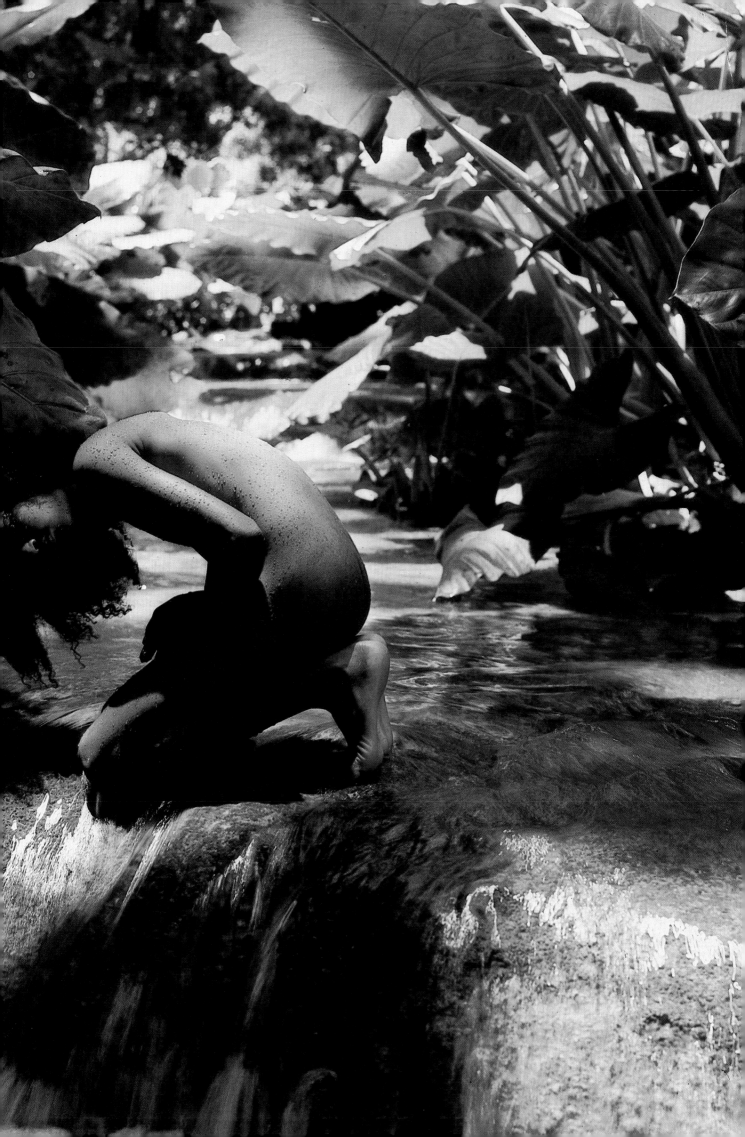

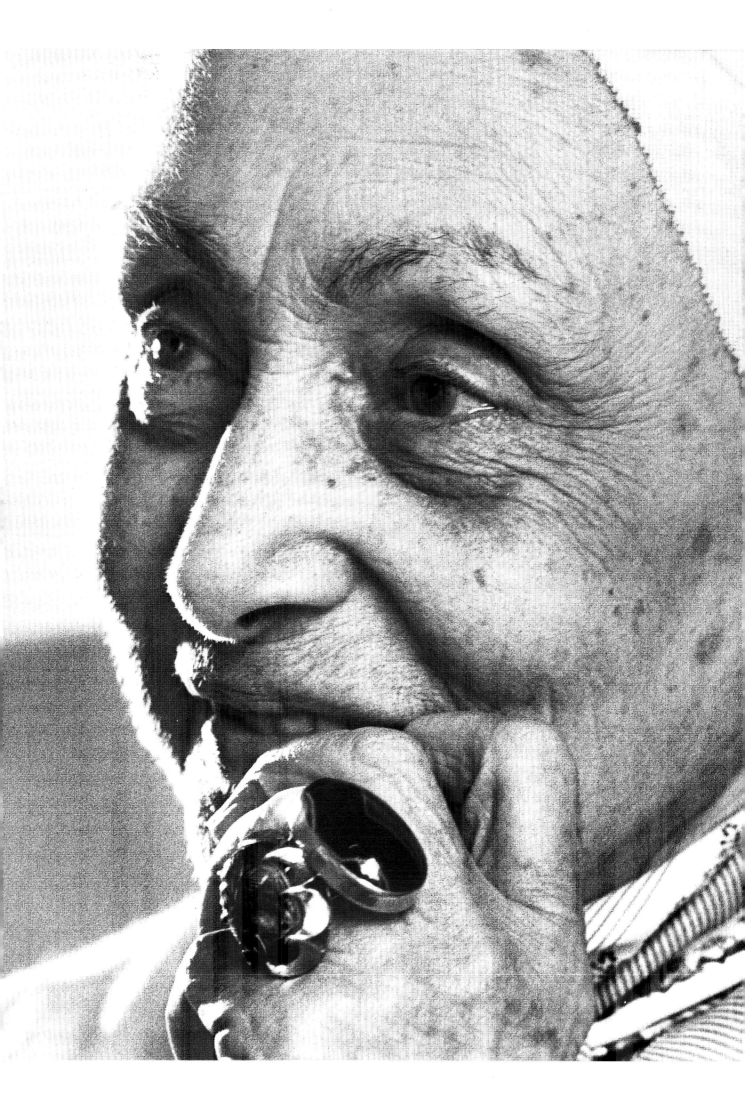

MADAME GRÈS

François-Marie Banier

'Allez-vous en, allez-vous en!' C'est l'invariable réponse de cette femme à qui sans cesse on vient demander qui elle est, comment elle crée, d'où vient sa magie. 'Allez-vous en!.' La voix est douce, très douce, affectueuse presque. 'Personne n'a à me connaître,' c'est que Madame Grès, que la plupart appelle Mademoiselle, ne pense comme personne, ne répond à personne. Connue pour ses robes, sa mode ne se démode pas plus qu'une pyramide d'Egypte, que la statuaire grecque, elle est intemporelle. Ce qu'elle fait ne s'explique pas davantage que son beau visage qui semble ne tenir qu'à un fil, ce trait, profond et sûr. Peut-être est-ce lui qui renferme l'énigme, on dirait qu'il descend du turban qui la coiffe, qu'elle-même a noué ce matin.

J'ai écrit quand je l'ai rencontrée pour la première fois il y a quelques années que c'était Mère Angélique de Port Royal et Gertrude Stein à son arrivée à Paris. J'avais beau ajouter en moins intellectuelle, en plus mystérieuse, je n'avais rien dit de cette femme si secrète. Aujourd'hui, peut-être pourrais-je en dire davantage mais je n'en ai pas le droit. D'abord ce ne serait pas tellement plus, ensuite Madame Grès n'existe pas. En fait, si ! mais que ça se sache, elle ne le veut pour rien au monde. Je ne dirai donc rien de sa façon de vivre, de son parfum, de sa demeure. Je lui demandais tout à l'heure pourquoi est-elle toujours si élégante. 'Aujourd'hui, c'est pour vous — ce n'est pas pour moi, vous ne comptiez pas me voir — alors c'est pour les murs.'

Sérieuse, et simplement elle travaille et sans cesse. Et ce qui compte pour elle c'est ça : les femmes, la beauté, sa maison de couture dont elle est le chef, et Paris et les mains de ces artisans dans la plume, l'écaille, la dentelle, le luxe et encore Paris dont elle est la grande prêtresse.

Rare, bien qu'elle craigne la solitude elle se tient à l'écart de cette société à laquelle elle n'est pas indifférente puisque ses femmes elle les change en fleurs, en flammes, ou simplement en autre femme. D'un coup de ciseau elle donne le jour à une épaule, découvre un buste, laisse deviner un sein. Et croyez-moi, ce diable de femme a plus d'un tour dans son sac pour arriver à ses fins : apprivoiser le beau.

Mais qu'est-ce que cette femme ? A mesure qu'on s'approche d'elle, elle recule. Sans doute, cette distance, lui permet de mieux voir, de mieux sentir, de mieux juger des volumes, des proportions, des couleurs. Il faut l'alimenter cette inspiration. C'est avec elle, de cette Inconnue qui la possède, et dont elle dépend, qu'elle vit solitaire. C'est avec elle que dans son silence elle dialogue car deux fois par an, à date fixe, il faudra, l'air un peu navré, comme si elle commettait une bévue, délivrer ses secrets. Pour elle, seul ce moment comptera : le jour de la présentation. La veille rien ne sera prêt, le soir, ce sera fini. Fini pour elle qui pensera à demain nous laissant devant ses audaces, sa poésie, sa rigueur, sa sagesse, ses folies, ce qui a jailli de ses mains chargées de lourdes bagues. Les grosses pierres sombres qui dominent ses doigts, seules témoins de son travail, l'une marron glacé, l'autre noire veinée de blanc, savent, elles, comment Grès sait faire disparaître le métier, d'où vient la grâce, et qui est Madame, pardon, Mademoiselle.

ROSE KENNEDY
Lord Longford

There is no woman in the twentieth century that I admire more than Rose Kennedy, leaving out of the comparison my own family and the great spiritual leader, Mother Teresa.

I suppose that most people revere her most of all for her extraordinary courage in the face of unbelievable family tragedies, and certainly on that count alone I pay her the most respectful tributes. But when one studies the full story of the family (and I have myself written a life of President Kennedy), one realizes that her creative influence was at work throughout their lives, glorious and tragic and, in some cases, all too short.

Her style has always been superb in every sense, and behind it all has lain the immense religious conviction that I, at least, trace back to her Irish ancestry.

It is difficult to know the most appropriate quotation to choose from her own memoirs. I like the moment when Joe Kennedy, Ambassador to the Court of St James's, dressing for dinner at Windsor Castle, turned to his wife and said: 'Well, Rose, this is a hell of a long way from East Boston, isn't it?' But, on the whole, I prefer the comment of David Powers, Jack Kennedy's devoted assistant, who said of her: 'She had a greater understanding of precinct politics than anyone in our organization'; and then added the deeper reflection: 'She not only loved meeting people, but she cared about the people she met.' Everyone knows that that was true of Jack Kennedy, but it was just as true of his mother.

Photographed for Harper's Bazaar, 1937.

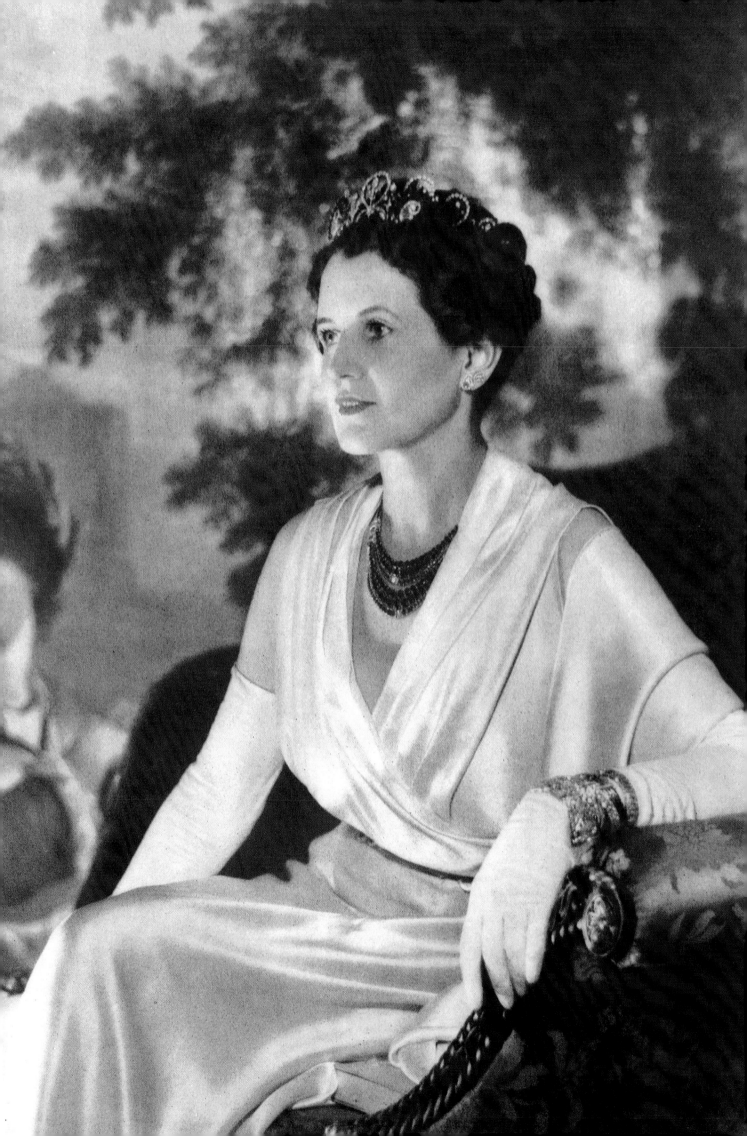

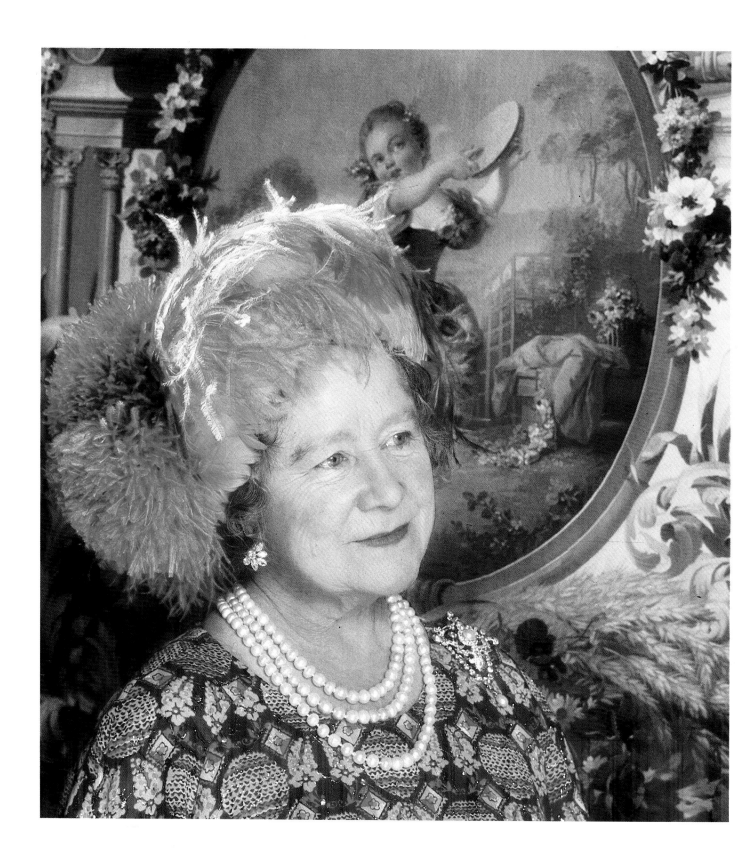

H.M. QUEEN ELIZABETH THE QUEEN MOTHER
Hardy Amies

Our other Norman, Sir Norman – or Normie to masses of people, his friends – should really write this piece. But, of course, he can't say what a smashing job he does of dressing the Queen Mother. I can.

It all started at the wedding of the Duchess of Gloucester in 1936. The princesses Elizabeth and Margaret were bridesmaids. Their mother, the Duchess of York, dressed at Handley Seymour of London, and at Lanvin of Paris, but shortly afterwards orders were placed with Hartnell as well. I was just beginning my career as a designer in London, and to my eye, inexperienced as it was, it looked like a love match, culminating in the triumph of the all-white wardrobe made for the new Queen Consort's State Visit to Paris in 1938. Our Normie's skill and taste were recognized by the French, who gave him 'Les Palmes Académiques'.

It was a love match between two very nice people. Normie speaks of the Queen's disarming sweetness and says that all care seems to fall away in her presence. I haven't met the Queen Mother often enough to be an authority: but enough to be able to endorse the opinion. On the other hand, I know Normie well enough to know that the description fits him as well.

Hartnell saw that the beautiful ladies of the Empress Eugénie's court wore just the kind of clothes which could help his customer to be royal, splendid and romantic. Being also Victorian they were also domestic, and, in a way, cosy. The jet set could not use crinolines: they were too bulky for air travel.

It is fortunate that the Queen Mother has a shoulder line admirably suited to such fashions. Her Majesty has looked her best, and indeed is sartorially immortalized, in a dazzling series of off-the-shouldered, fichu'ed, caped, flounced, crinolined and, of course, embroidered evening dresses, which the French call 'Robes de Style'. These have been so often photographed that Norman P. has probably sought a less hackneyed view.

The Queen Mother has many engagements by day. For these she chooses soft woollens in pastel colours. Parkinson has chosen to photograph Her Majesty dressed for the cocktail hour. It is the moment for relaxation after the rush of the day. The gentle soothing smile is there: but there is a twinkle in the clear blue eyes. You could not arrive at what must be wisdom without a sense of tolerance and humour.

INGRID BOULTING
David Bailey

John French, the famous English fashion photographer, always started a conversation with me with the words, 'You know, David…' The reason for this piece of useless information is that the first time I heard the name Ingrid Boulting was from his lips. Unfortunately, John has now gone to the big studio in the sky, but as he was famous for his reflected light, he must be quite happy up there. 'You know, David, you must take some photographs of Enid Boulting and her daughter Ingrid. You ought to do them in the forest with the sunlight streaming through the leaves.' That was as far as that one went, though the first professional model I ever worked with was Ingrid's mother, who scared the life out of me with her beauty. I don't remember her telling me about her beautiful daughter, but then you know what beautiful women are like about other beautiful women.

The first time I was struck by Ingrid's looks was, I think, in a Sarah Moon picture, nude from the waist up with the soft Pre-Raphaelite look that became so fashionable in the late 1960s and early 1970s, thanks to the enormous talent of Miss Moon. Ingrid and I did not hit it off at first with the way we saw images. She always wanted to look like Ophelia floating down the stream, which, in my opinion, had been visually polluted by all those dead flowers. The Millais thing was not really my forte. Others did it much better than I could.

Ingrid was always best with me when we were on trips together. I began to see that, behind this soft English rose, was a creature fearless, tough-minded and completely professional. On one occasion I was photographing her with a Zambian elephant in the background, and they are not the kind-hearted little jumbos that one finds in India. The white hunter had obliged us by tracking down an elephant with its left eye missing, and I remember yelling to Ingrid all through the session to keep on the left side of the enormous beast. She, of course, was very English and appeared completely fearless. I knew I was safe with her between me and old lefty.

A few months later we found ourselves on the desert islands of Fiji together. She would gaily swim with the coral sharks, which a local had assured us were completely harmless. I was not convinced, as even the jellyfish were a bit much for me, but Ingrid acted as if she was in some Beverley Hills swimming pool. Later on during the same trip we were walking by the shore together when a voice drifted across the deep with the message that he had got cramp and was drowning in the swift-flowing current. We both answered the call and swam to the rescue. I grabbed the unfortunate boy in the way they had taught me in the RAF, and started back to shore, the poor thing in my arms. Ingrid, swimming alongside, gave me instructions, which had a disastrous effect on the victim, because he started to hit out in every direction with all four limbs. The only reaction from Ingrid was to calmly inform me to knock him out. She followed this off-hand order by getting the giggles so much that I thought she was going to drown as well. So, apart from being rather brave, she apparently has a great sense of humour, even if it can show itself at very odd moments.

I haven't seen much of Ingrid lately, except, as they say, in the movies. I have fond memories of this giggling Ophelia, and miss working with her, because she always came through for the camera, which, apart from being money in the bank, was a satisfying and beautiful thing in its own right.

Ingrid Boulting at Laycock Abbey

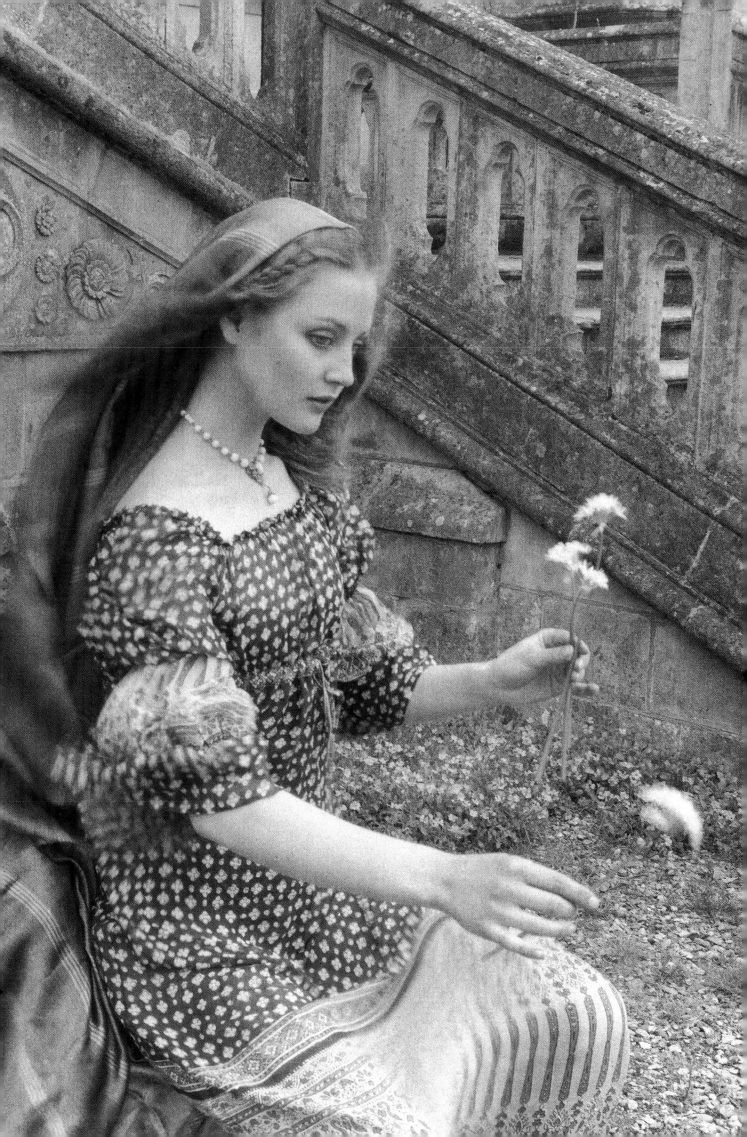

DAME SYBIL THORNDIKE
Sir Cecil Beaton

Sybil Thorndike, the daughter of a Canon, was a devout Christian, a warm-hearted out-going person who would do anything for anybody. No doubt because of her inability to say 'No' she played more parts in more plays in more theatres in more countries of the world than possibly any other actress. From the age of twenty-one to the end of her life, she was almost continually on the stage; in Shakespearian repertory in America at the very beginning of her career, she played one hundred parts in twenty-five plays.

Sybil continued to act in plays by Shakespeare in London and in theatres all over England, in plays by many contemporary playwrights, and in Gilbert Murray's translations of the Greek tragedies. She could be said to have 'made her name' in 'Grand Guignol'. I like to remember her as a pretty young girl with blonde curly hair in 'Advertising April'. One of her most unforgettable performances was in Shelley's 'The Cenci'; but perhaps her most renowned role was 'St Joan', which George Bernard Shaw wrote specially for her.

Sybil revelled in 'great women' parts; her strong voice resounded throughout the auditoriums; her dominant personality stirred the audiences; it was a purging of the effects of pent-up emotion – a catharsis of her own basic instincts. She was not all sugar, and could be wicked – only towards her fellow artists, I may add.

Sybil Thorndike was intensely interested in all forms of artistic expression, and at the start of the century was deeply involved with other actors and actresses, writers, poets and musicians, in forging a new way of thinking, a new movement.

In the early 1920s she took on the management of various London theatres and formed her own company with the help of her husband, Sir Lewis Casson. She played 'Phèdre' in French; she gave poetry recitals in diverse places and in aid of numberless causes. She had a phenomenal memory. In wartime she took her talent to the troops in battle areas, and brought 'Macbeth' to the miners at home. She made films. She appeared on television. She played the piano beautifully, mostly for her own pleasure.

Sybil was tireless, indefatigable and altogether magnificent. She was loved by millions; was given the Freedom of the City of Rochester, where she spent her childhood; and is buried in Westminster Abbey, which is entirely fitting.

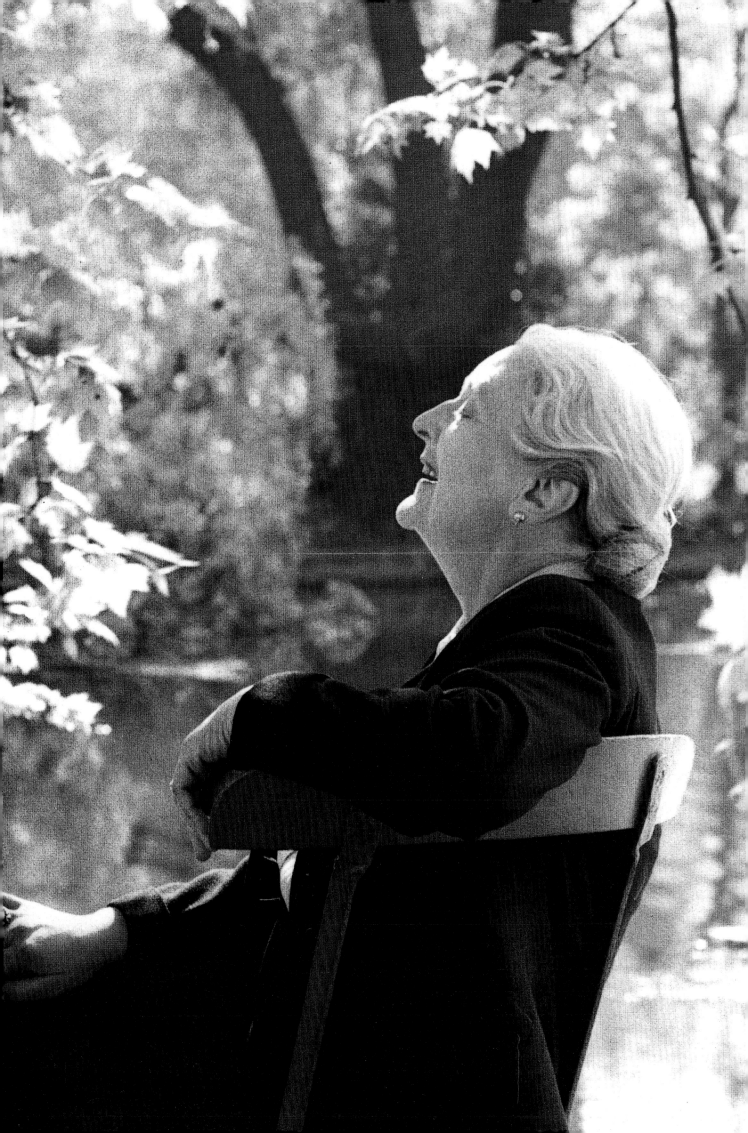

James Lees-Milne

Virginia Woolf, with whom Vita Sackville-West's name will always be associated, once said that her friend was no author. 'She writes with complete competency, and a pen of brass.' This acerbic remark was typical of Bloomsbury's most exclusive member. For Bloomsbury, with few exceptions, did not approve of Vita any more than Vita cared for Bloomsbury. And the reason? Vita was not sufficiently logical or, strictly speaking, professional: or politically left wing to satisfy their Fabian standards. Indeed Vita could never be a member of a clique. She was, on the contrary, a loner, a bundle of emotional contradictions and an unashamed patrician. Daughter of one of England's oldest families, she was brought up at Knole, that paragon of romantic stately homes. Her adoration of Knole transcended her love of husband, family and friends. She felt for Knole as a tigress feels for its cub, atavistically, possessively, passionately. In her Sackville veins there mingled the blood of her peasant grandmother, the beguiling Spanish dancer, Pepita. It gave Vita an affinity to wild, untameable nature. It made her capable of irrational hatreds, and irrational loves. It made her one of the most fascinating personalities of her generation, and also one of the most lovable. Virginia Woolf may have been unduly tart about Vita's writing, but she aptly portrayed her in the volatile, epicene, poetic Orlando. Poetic –

It is of course by her poetry that Vita Sackville-West would wish to be judged by posterity. She was unduly modest about it, aware that to the ears of her contemporaries it sounded old-fashioned. It was certainly traditional. 'The Land' will undoubtedly rank with the great paeans of the twentieth century. Vita's novels are not likely to retrieve their popularity of the 1920s and 1930s. Her biographies will always be respected and enjoyed.

Today Vita is probably best known for her contribution to gardening and her marriage to the writer, Harold Nicolson. At Sissinghurst Castle, Kent, the two of them created a garden, the beauty of which has not been eclipsed by any other within modern times. In their unconventional marriage, this distinguished pair achieved a union of reciprocal love that can hardly ever have been surpassed in history.

Vita was a very beautiful woman, tall and slender. She moved with a peculiar languid grace. Her dark hair, proud features and velvet complexion were inherited from her Spanish forebears. Her voice was as rich, warm and mellow as southern wine. To those companions with whom she felt at ease she was (surprisingly perhaps) the gentlest, as she was the most understanding and the rarest of women.

Miss Pearl

Lady Helen Windsor

TWIGGY

Michael Parkinson

Those who look at beautiful women through a camera lens, often tend to be blasé about what they see. We who stare at their work – whether it be in a magazine or on film and television – can only envy them their task. When we meet them we tend to go in for a lot of: 'Go on and tell us, what is she <u>really</u> like?', and similar masculine nudge-nudge, wink-wink routines.

More often than not those men whose career is to point a camera at God's loveliest creations will smile a sad smile and dismiss our eager question with a shrug as if they cannot comprehend what all the fuss is about.

All of which explains the quality of the compliment I am now about to recall. Given that cameramen are blasé creatures, I do not expect, or get, much reaction to any of the guests on my television show. No matter how outrageous the behaviour, how daring the dress, how blatant the sex appeal, the cameramen go quietly about their tasks, seeing everything and saying 'nowt'.

Then one day Twiggy came on my show and as she was standing in the studio doing nothing in particular, awaiting her turn to rehearse, I noticed one of the camera operators discreetly circling her until he had inspected her from every angle.

Later I sought him out and asked him what he was doing. 'An experiment,' he said. I asked what kind of experiment. 'Well', he said, 'I've been in the business for more than twenty years and I've looked at some of the world's great beauties but it has always been possible to find an angle, if you so wanted, that was unflattering to the subject. In other words there was always one flaw in the beauty. I came to the conclusion that nobody's perfect. Then I looked at Twiggy, shot her from every angle, and couldn't find anything but perfection. She is the most beautiful girl I've ever seen. It's impossible to take a bad picture of her!'

If she lives to be a hundred, Twiggy will never know higher praise than that. I can only endorse the compliment. There is about her a beguiling mixture of childlike innocence and sophisticated elegance. Norman Parkinson is a lover of beautiful things. Many times his skill has been in enhancing a woman's face so that the reality becomes an illusion. In photographing Twiggy he has simply done her justice. There is no higher praise; and no other way to approach the task.

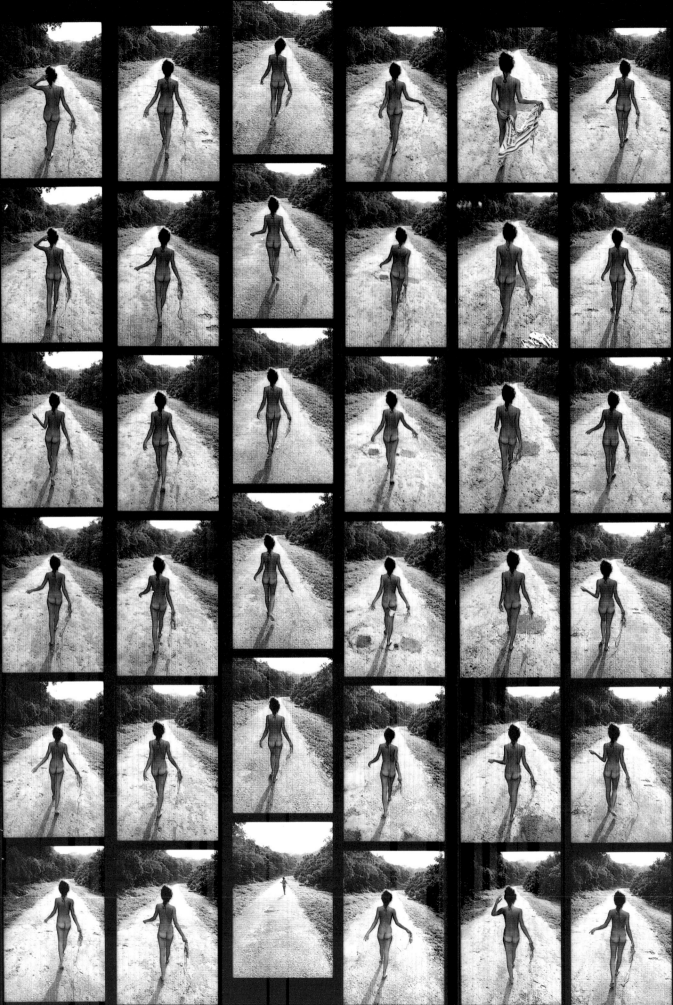

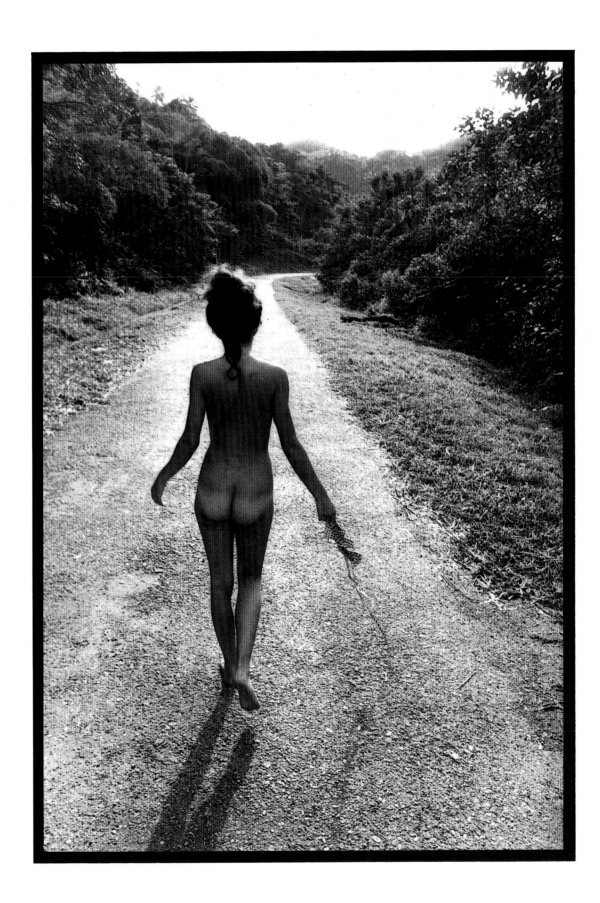

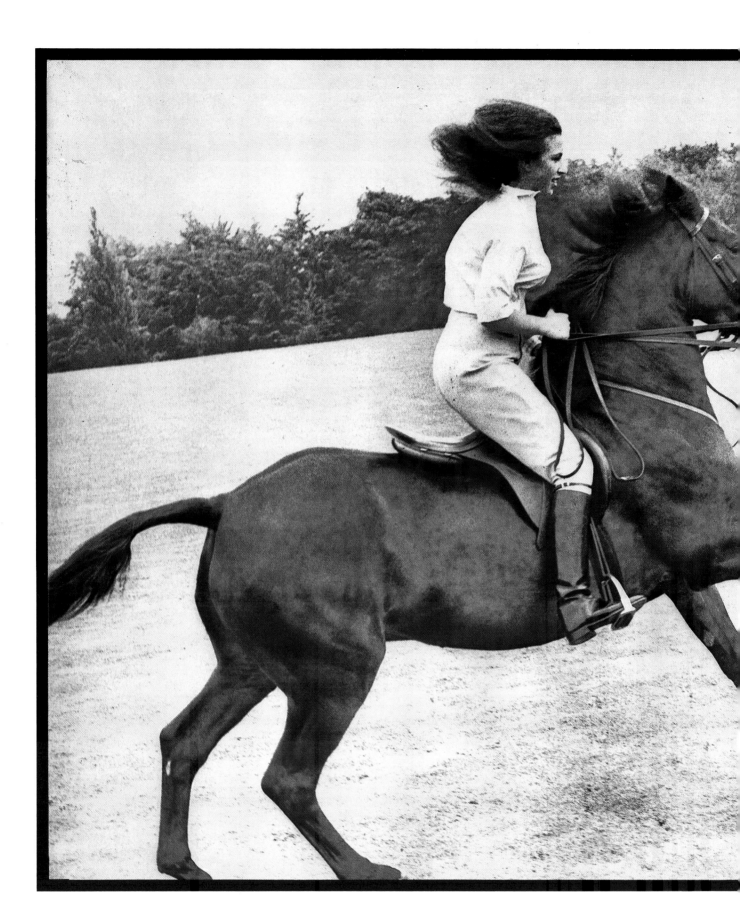

H.R.H. THE PRINCESS ANNE
Jeffrey Bernard

There are very few people who look more comfortable on a horse than Princess Anne. She looks, in fact, more comfortable in the saddle than do most of us in an armchair. She is positively indigenous to fetlocks, fences and falls. I remember once seeing her depicted on television sitting at and in the wrong side of a water jump, and she looked as much at home there, in that bleak bath, as she does when pictured with her husband, the captain, on a formal occasion and in a more royal setting. Admittedly she's no Piggott or Jonjo O'Neill, but the heart gets closer to the mouth when she jumps on her steeds than it does watching the professionals, simply because one fears for those Hanoverian bones. I fancy she'd rather stand on an Olympic plinth to be decorated with either gold, silver or bronze than she would stand on ceremony.

Not that ceremony is, by any means, anathema; clearly this woman was born to terrify, and there can be no question of her intuitive authority over her subjects human and objects equine. I'd like to see her name a horse Hyperion, look it in the eye and dominate it from under her Fortnum's headscarf. In just about twenty-five years on the Turf I have seen processions of the best thoroughbreds winning the Derby and Ascot at its most royal, but never have I seen anything so regally demanding as the jodhpur-clad thighs of her Royal Highness hugging her willing, happy, happy steed.

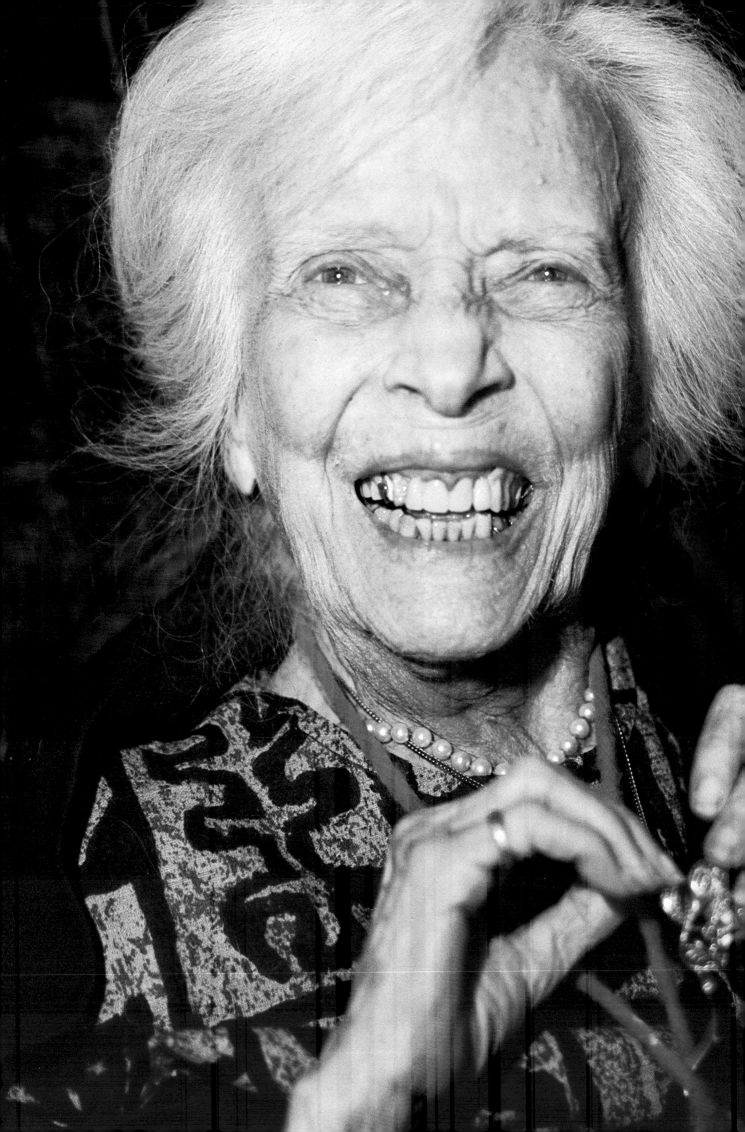

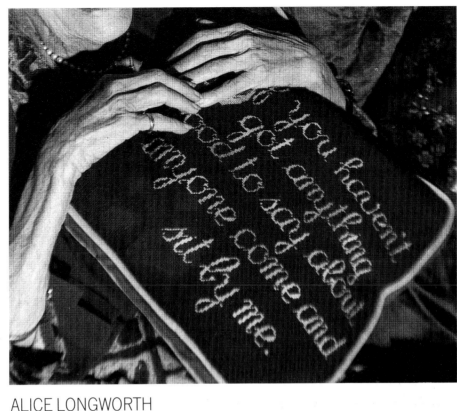

ALICE LONGWORTH
daughter of Teddy Roosevelt

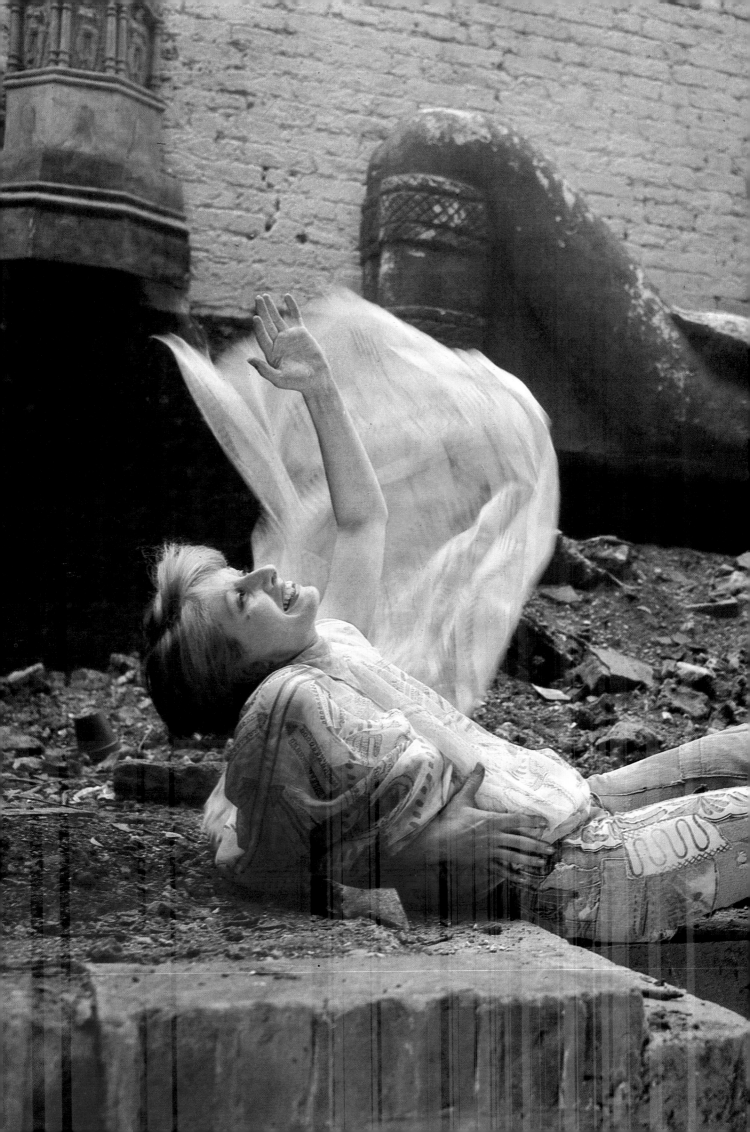

ZANDRA RHODES
Russell Harty

A bank of burning arc-lights, four silent prowling television cameras, seven hundred banked and baying guests, an inquisitive host and a sharp-watching floor manager do not, on the whole, combine to produce an atmosphere in which it is easy for charm to display itself. These conditions, however, prevailed for my first, my only so far, meeting with Zandra Rhodes.

I was startled by her appearance and, like a mariner observing the Eddystone Light, I was initially wary of the shocks and shallows beneath this flashing exterior. The voice reinforced my fear. As Shakespeare says, with his accurate finger so often on the paradoxical nature of things, 'Thus may the outward shows be least themselves'.

She is the least flashy of ladies. She is thoughtful. She is extremely clear-headed. She has a formidable tenacity of purpose. She knows that when heads turn in her direction and eyes come out like chapel hat-pegs at her approach, she is creating the desired effect.

'What did you make of her, then?' was the universal response to our first public meeting.

'What did you think of her?' I threw back.

The response was as unanimous as the question was universal. When you have got your breath back and travelled up to the head and back down a bit to the heart, you are in a position to take off with a lively companion. The Eddystone analogy is not all that far-fetched. It towers above its surroundings. It makes its signal unequivocal. It helps ditherers down below. It's dependable. And, if you venture anywhere near its sphere of influence, it is inescapable.

MRS LYNDON BAINES JOHNSON
Douglass Cater

How to define beauty? Those who know her agree
that Mrs Johnson is not 'photogenic' which is to say
that the camera has never captured the beauty we
perceive in her. First it is that neither shutter nor
film seems capable of recording her extraordinary
concert of vivid colouring, enormous vitality, and
lithesome grace. But the failure is more serious for
there is that interior beauty.

A child of America's deep South, whose
christian name 'Claudia' never fitted, she grew up
to give dignity to the affectionate nickname
'Lady Bird' bestowed on her by a nurse. Wife of a
politician of relentless energy and force, she held
her own, reinforcing him without becoming
sacrificial lamb to his ambition. Someone needs to
write the definitive analysis of how beauty and
gentleness survive amid such stress.

Then First Lady of the nation: at risk of gross
oversimplification, one L.B.J., the President, was
dedicated advocate of a bigger <u>quantity</u> of the
good life – for the disadvantaged, the disabled, the
discarded. Even goods like education and health
were to be increased in gross output so that all
could share more equally. The other L.B.J. devoted
her energies more to a better <u>quality</u> of life. She
led the shock troops on behalf of causes like
beautification, carrying her assault against
ugliness even into the nation's urban and rural
slums.

Finally, widow of a President who had
endured tragedy before his death: Lady Bird
Johnson has not retreated into self-pitying
retirement, but gives of herself to build living
memorials to his name. Not once has she been
quoted in anger or bitterness against those who
have sought to villify her husband. I have never
heard her utter a mean or belittling word about
another.

And those are the definitions of true beauty.

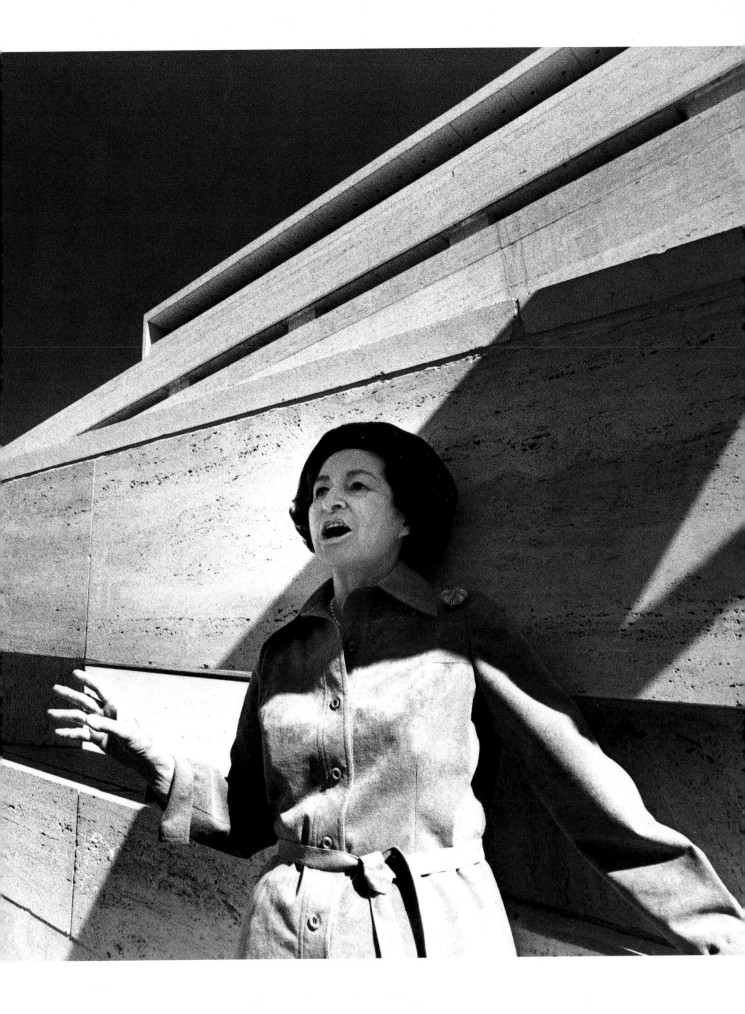

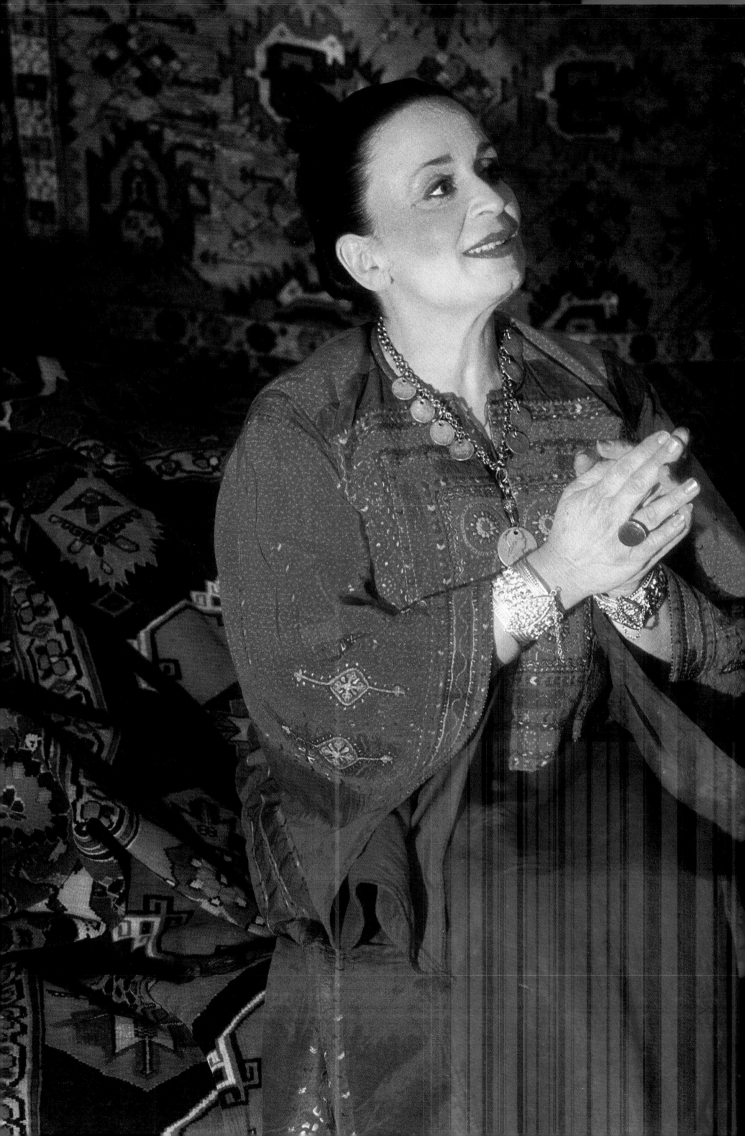

PRINCESS DINA ABDEL HAMID

Alastair Duncan

It is in many ways a misfortune to be born of greatness into a world increasingly materialistic in its attitudes and values. Criteria, once recognized and admired, are now often discounted, and those to whom birth has given a sense of duty and service can find themselves estranged in an unsettled society.

Dina Abdel Hamid is the great-granddaughter of Sherif Aun Al Rafiq, Emir of Mecca, and is of the forty-first generation in direct descent from the Prophet Muhammad. Her father left Arabia with the Hashemite leaders and settled in Cairo, where Dina was born. Her mother's father was a distinguished Circassian religious leader whose family left the Caucasus and settled in Turkey after the defeat of the Imam Shamyl by the imperial armies of Russia. An only child, she describes her upbringing as being objective and liberal; she was not conscious of being treated so much as a girl but as a person in her own right. With the influence of her parental background, it is not surprising that, at an early age, she was aware of the regional divisions within the Arab world, and of their need for cohesion and unity to resist and overcome exploitation by other powers. Her ambition crystal-lized into a desire to write Arab history for the Western world in a way that would counterbalance widespread misconceptions.

She studied English at Cambridge University, the better to equip herself to reach the hearts and minds of those for whom she hoped to write. While she did so, she absorbed the liberal sciences of the twentieth century. With her parents' blessing, she developed her objectivity of mind beyond the confines of the tra-ditional upbringing of an Arab woman. She returned to teach at Cairo University, but after less than two years she found herself drawn back into that traditional world as Queen of Jordan. She was a Hashemite and her sense of duty carried her on its course. But as so often happens in life, the all-important timing was not right, and it was to be many years before the trauma of hopes unfulfilled and tragic difficulties were reconciled.

It was as Queen that she first felt responsible for the welfare of the refugees from Palestine, although she had long felt deeply for those people whom the Hashemites had helped to free from Ottoman hegemony, but had been unable to protect against the incursions of Zionism. Though no longer Queen, she could not relinquish her sense of responsibility for her Arab brothers and sisters.

Sustained by the zeal and dedication of her husband Salah El-Ta'mari, she has continued to devote herself to the cause and welfare of this unjustly treated people, and by so doing, has used her determination and strength to continue as a leader even though she was compelled to strike out even further away from the conventions of her more conservative sisters. For Dina is strong: strong with the gentle strength of silk rather than that of steel. Imbued with her conviction for Arab unity and identity, she pursues her goal of a future in which Palestine will once more embrace people of all faiths upon terms of true compassion and equality before God. But always in her mind is the call of the Hijaz and a deep yearning for that other Holy Land and her Hashemite inheritance.

After Kees Van Dongen

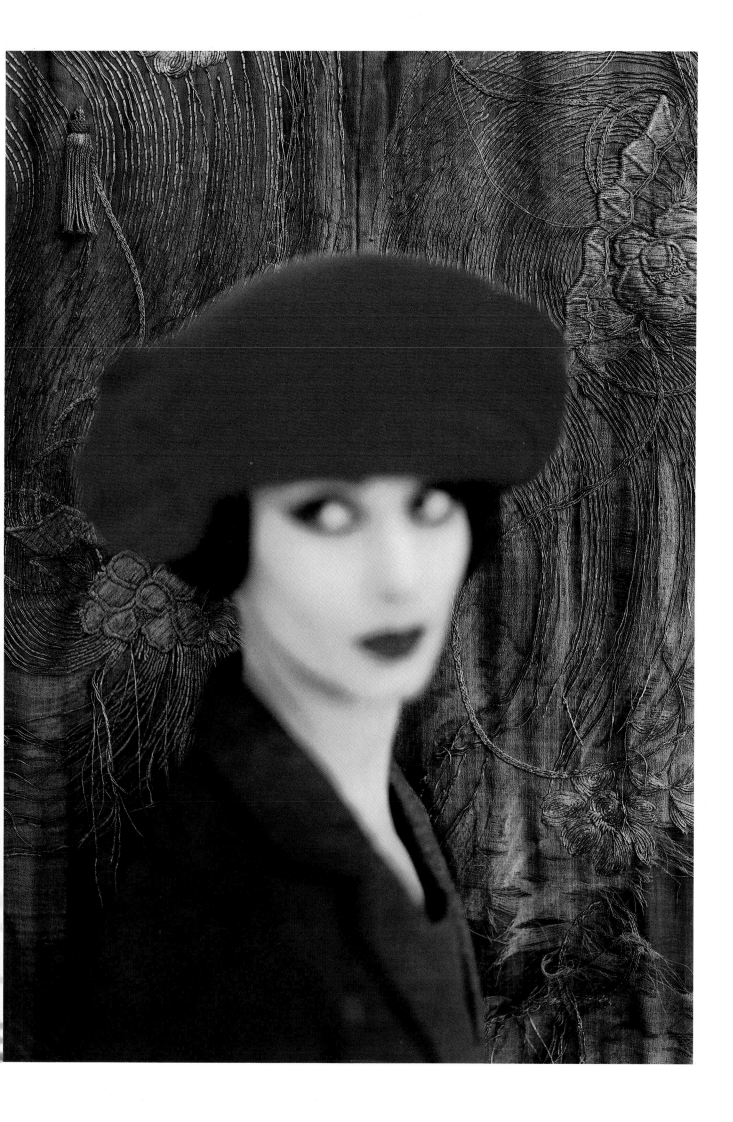

BEVERLY MANLEY

Barbara Gloudon

Beverly Manley, age thirty-six, is a former broadcaster who, in 1972, became the wife of Michael Manley, Prime Minister of Jamaica. She shunned the traditional ribbon-cutting image of the public official's wife to concentrate on a programme in keeping with her husband's government. She spearheaded a national campaign for more basic schools, day-care centres and recreational areas for pre-school children, setting the example by establishing a model project in the grounds of the official Prime Minister's Residence.

She is a leading activist in the struggle for the full equality of women, which she sees as a part of the larger struggle for an end to all forms of exploitation, which is only possible in a socialist society. In this context, she gave dynamic leadership as Jamaica's patron of International Women's Year in 1975, and was a key-note speaker at the world-wide forum in Mexico City. She is national convenor of the Women's Movement of the People's National Party, the largest political women's organization in Jamaica.

In 1975 she went back to being a student, enrolling at the University of the West Indies campus in Kingston for a three-year course in politics, literature and history, leading to a BA degree. This, for her, was another stage of 'moving on', and becoming better equipped 'to help those most depressed and most oppressed'. She studied the varied political systems of East Africa, Latin America and China. The history curriculum took her from pre-Columbian to modern times. Of particular delight was the literature study, which awakened new analytical interest in the growth and development of West Indian culture. The university experience was a challenge, not only in a resumption of formal study, but also in the real task of combining official duties and political responsibilities with full participation in student life.

Beverly Manley hopes to continue her contribution in the field of communications in Jamaica, most likely through teaching, involving history and culture. She is the mother of a four-year-old daughter, and is step-mother to three young adults. The success with which Beverly Manley combines her roles–political activist, mother, wife, student–represents an advanced stage in the development of Caribbean women.

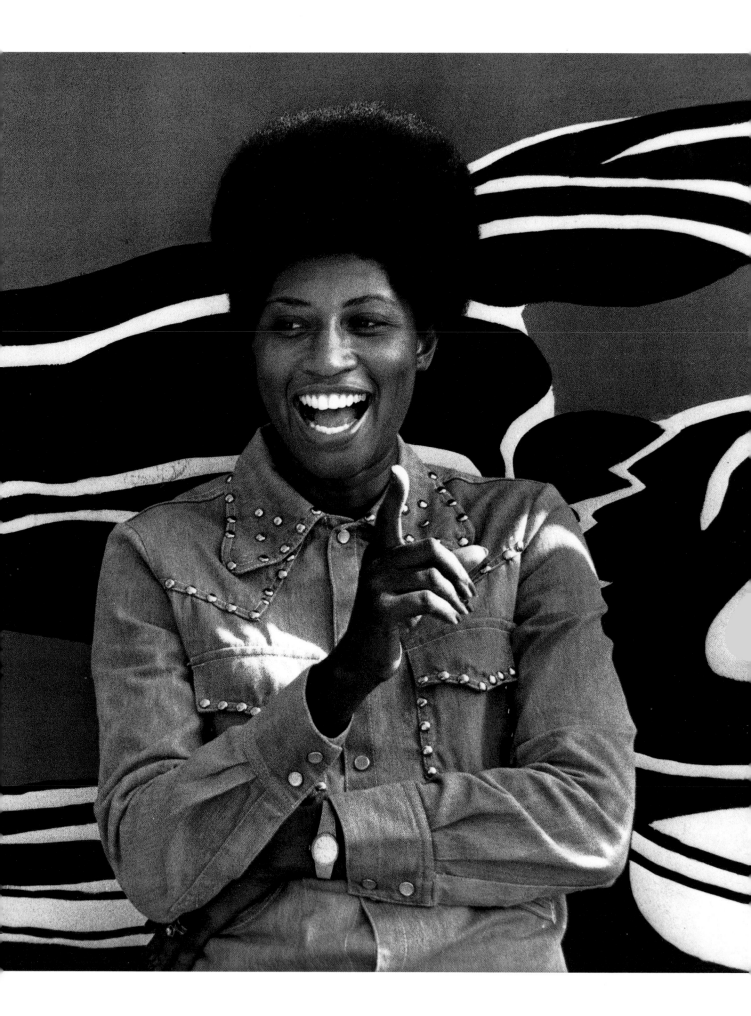

BARONESS MASHAM OF ILTON, COUNTESS OF SWINTON

Lord Crawshaw

In crossing the rough sea, it is a great advantage to have people of character and resourcefulness in the same boat. There must be vast numbers of people, including me, who have cursed their luck to have landed in the disablement boat that have been fortunate to find Sue Masham as a leading member of the crew.

She has tremendous human concern allied to considerable medical knowledge and a canny Scottish common sense and humour. This is a lethal combination when used to melt unnecessary starch or bogus bureaucratic etiquette. She has the nose of a pointer for finding awkward problems that have been swept under the carpet. She drives her car thousands of miles a year around the country, to speak at meetings or visit medical establishments. She is the founder Chairman of the Spinal Injuries Association and works for innumerable charities, including the Red Cross.

We marvel at her energy and worry about her health, but she appears to thrive on it. Her husband, Lord Swinton, is a Yorkshireman with a heart as massive as his frame, and together they dispense endless hospitality at their home near Masham to all and sundry, from prime ministers and Bing Crosby to Borstal boys.

She was made a life peer in 1970, and has since taken an active part in the House of Lords. Heaven help the minister who is improperly briefed or tries to dodge the question. She has become a Roman Catholic, probably out of admiration for the nursing and the teaching of the nuns, and her adopted daughter goes to a convent school.

One way and another, she is a very good girl to have on your side, and a very attractive one too.

DIANA VREELAND
Norman Parkinson

'Where is the glove editor? I asked for biscuit-coloured gloves. All you have brought me are beige.'

Those of us who worked with Diana Vreeland on 'Vogue' in that extraordinary and unsettling decade of the 1960s must still hear her in our dreams; and wake in the small hours, wondering how to achieve the impossible.

For more than three decades, hers was the oracular voice in the world of fashion. Her word set the tone to each new subtle trend or every outright revolution. Some saw her power as immense. The fact was she had her finger on the pulse. Nothing happened without her being in at the start of it.

'I asked for straw hats. These will not do. These come from Panama.'

Her impossibilities were legion. Yet, you realized later, in an extraordinary way she always managed to be right. If the world was out of joint, it must be simply stretched a little in her direction.

'Parkinson, we are sending you to Tahiti and we are sending you with a collapsible plastic city. You will dig holes. You will enter people's lands. And you will erect this plastic city against the dramatic mountains.'

'But Mrs Vreeland. What about the law of trespass?'

'Please don't bother me with incidentals.'

Few others have taken in on a personal level such an all-embracing sweep of twentieth-century fashion. Diaghilev, Nijinsky and Chaliapin were guests in her parents' house in Paris. This was the Paris where, before the First World War, modern fashion began with Paul Poiret, who invented the hobble skirt, then added to it the draped tunics and capes which took their motifs from the craze for things Far Eastern and the exotic style of the Ballets Russes.

'Style' has, for her, been one of the key words, the other one is 'taste'. Beauty and glamour are nothing without style, and taste, she has said, is education.

She became fashion editor on 'Harper's Bazaar' in the 1930s, remained there till 1961. Then, at 'Vogue' in the 1960s, she made it the very hub of the universe of style and fashion. The runs of these

magazines for those years make, in retrospect, the most extraordinarily penetrating record of shifts in fashion over what seems like a period of time travel.

It was utterly appropriate, when her time on 'Vogue' ended, that the Metropolitan Museum of Art in New York should ask Diana Vreeland to be curator of their Costume Institute. There today, under her priestly custodianship, history has never been more alive. There, if we will listen and understand, she continues to interpret for us the cycles of demise and resurrection that are fashion's keynote.

An astonishing woman, who, Truman Capote has said, is like 'some extraordinary parrot – a wild thing that's flung itself out of the jungle and talks in some amazing language'.

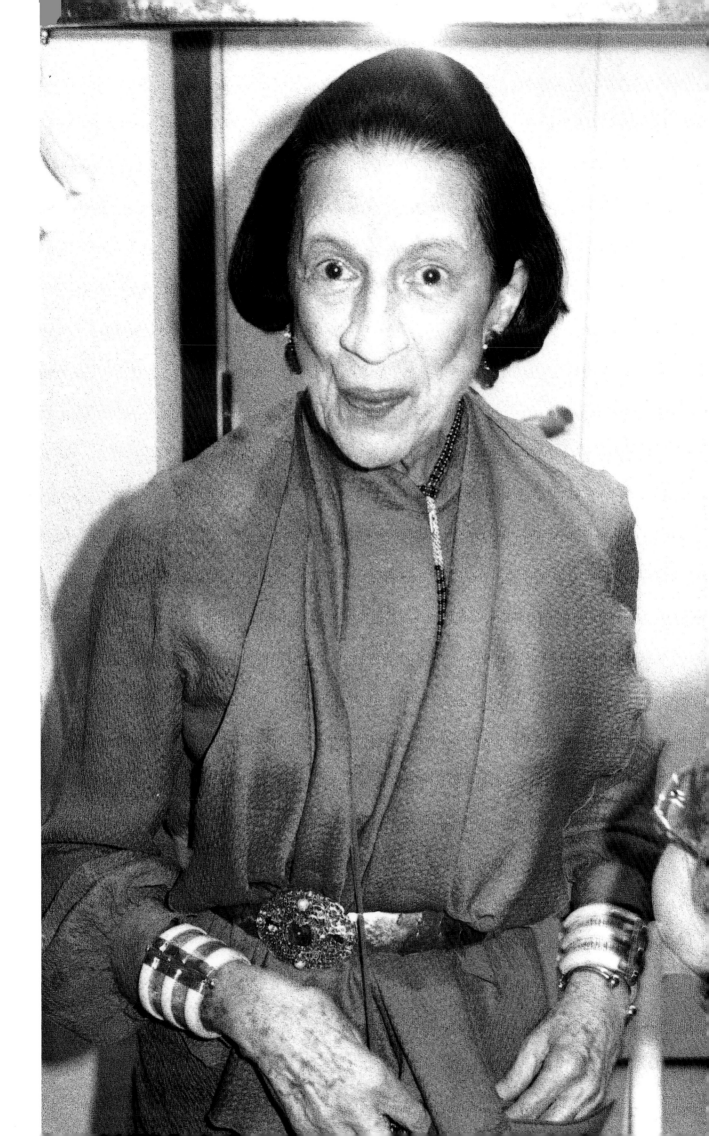

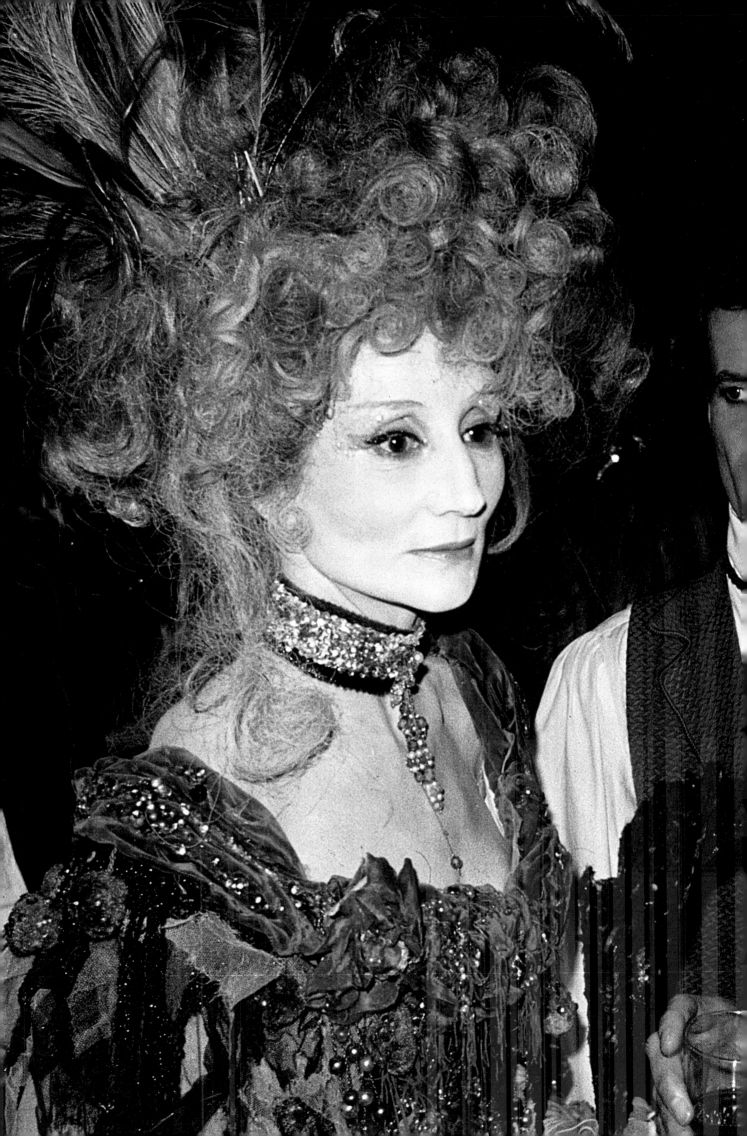

VICOMTESSE DE RIBES, NÉE JACQUELINE
DE LA BONNINIÈRE DE BEAUMONT
Tenue de Fête.

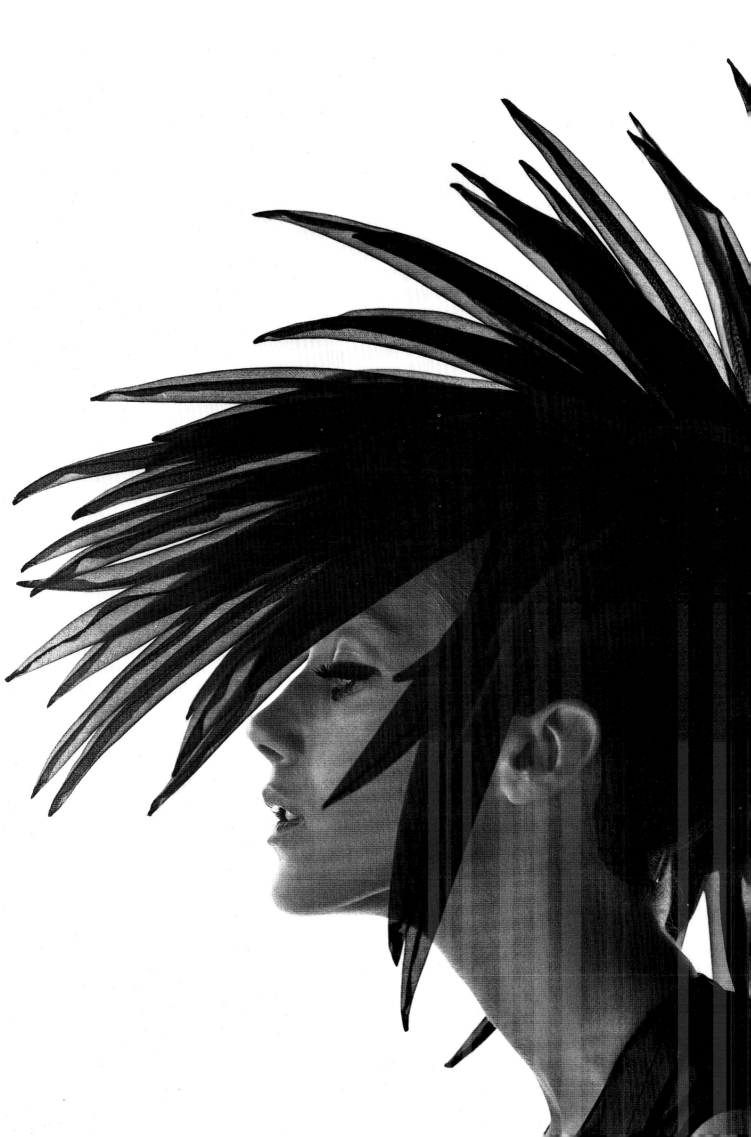

MARISA BERENSON

A photographer who wishes to remain anonymous was once leaving the dressing-room behind Marisa Berenson and he said, 'Goodness, your backside is collapsing like Mahatma Gandhi's dhoti.' She rounded on him and exclaimed, 'Who's she?'

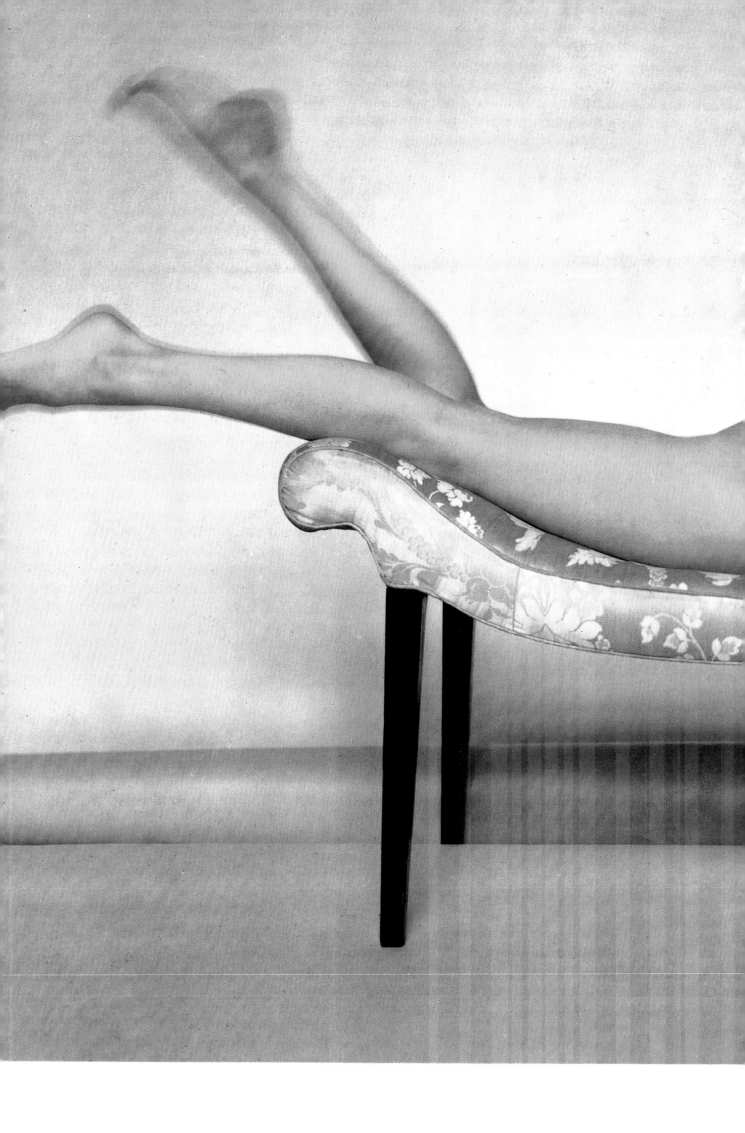

VIVIEN LEIGH
William Shakespeare (quoted)

CHARMIAN (of Cleopatra):

> Now boast thee, death, in thy possession lies
> A lass unparallel'd. Downy windows, close;
> And golden Phoebus never be beheld
> Of eyes again so royal!

– Antony and Cleopatra, Act V, scene II

MRS BOEHM

Monsieur de Min,
Manager, Le Grand Hotel, Rome

A constant client of Le Grand Hotel,
Rome, where she stayed after she was
widowed, with an excellent memory she
loved to speak of the past. She was a
witty, brilliant talker, and counted among
her friends the most important names of
the cultural and musical world. Together
with Mr Cecil Roberts, the faithful friend
who stayed near her until her departure
from us, she went for over thirty years to
each opera première and to each
performance of the Accademia di Santa
Cecilia.
 She loved flowers and little hats. You
would never see her without a hat. Maybe
she wanted to appear a little bit taller
since she was a very, very little lady.
 Her preferred drink was milk, which
she sipped like it was champagne. She
resembled a little bird, and like a little
bird she passed away without making a
noise.
 She donated over a million dollars to
to the hospital where her husband, a
skilful doctor, once served the needs of
humanity.

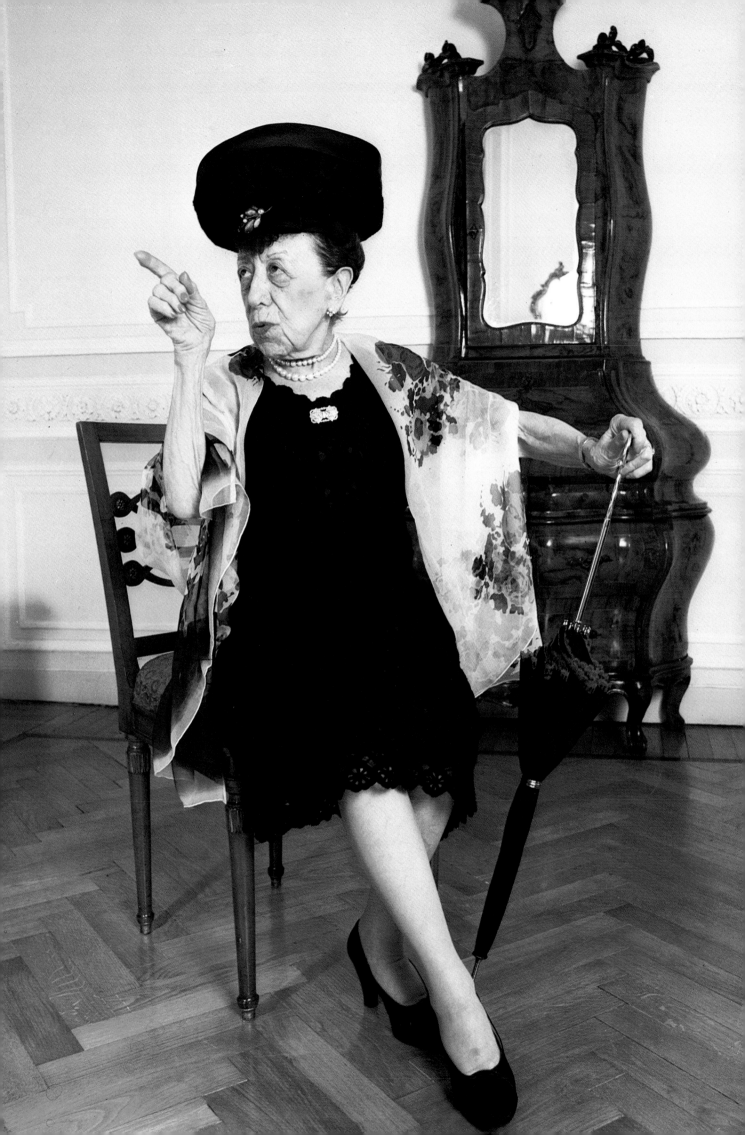

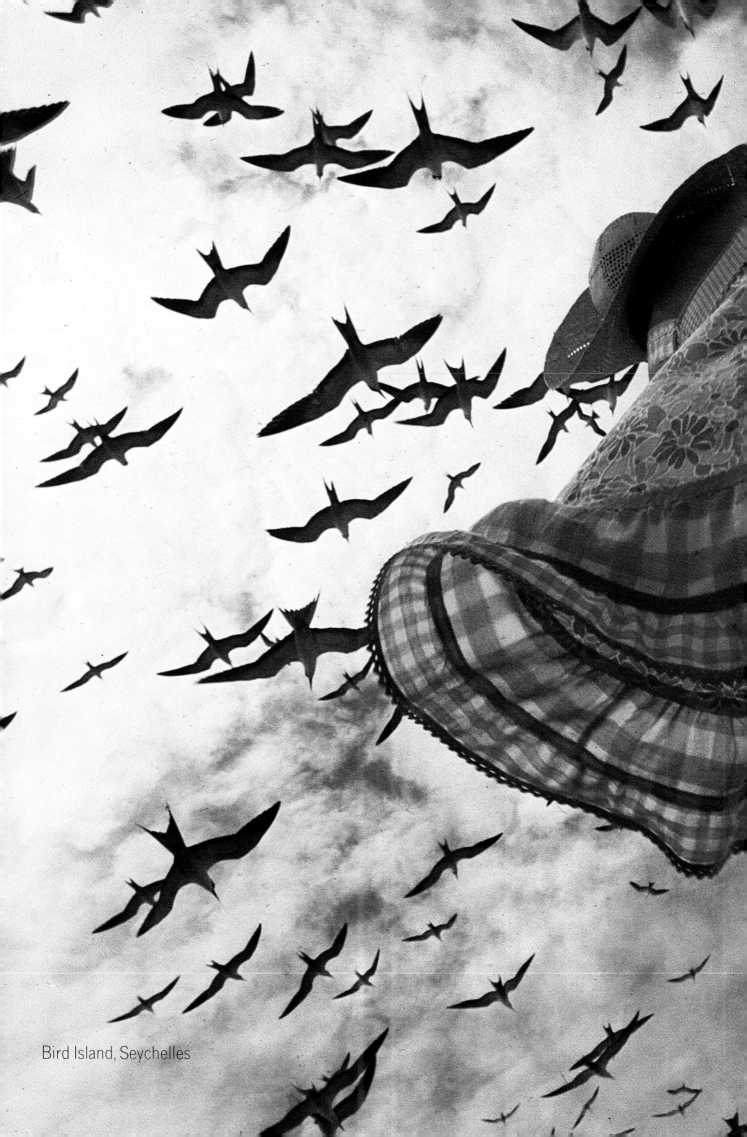

Bird Island, Seychelles

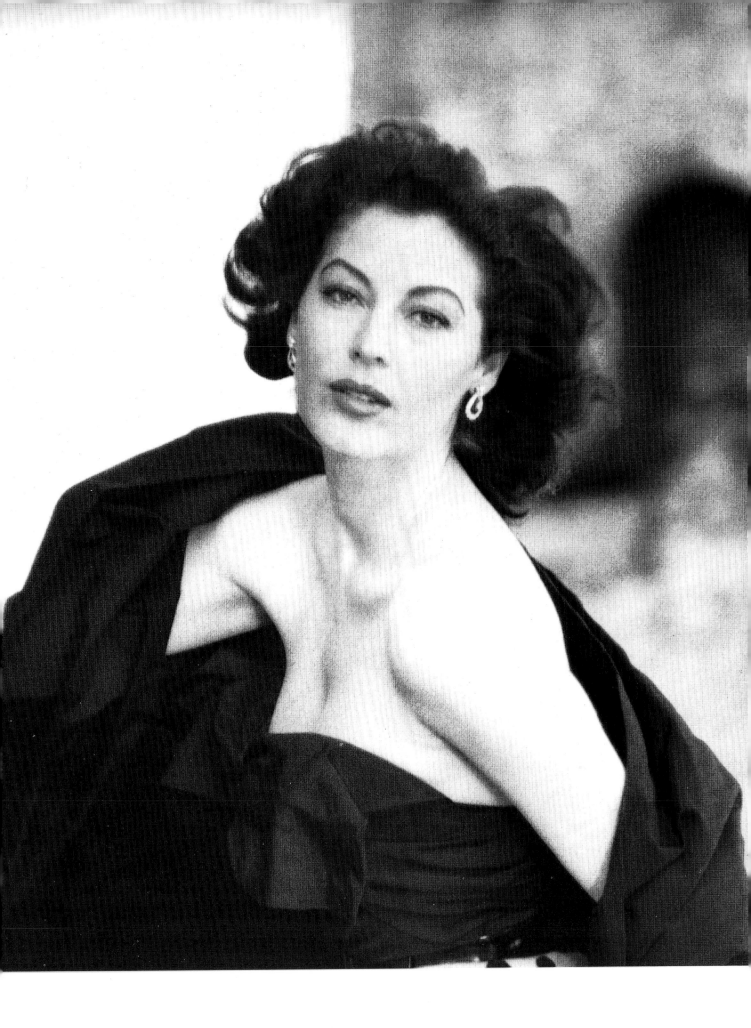

Mary Ann Slinger

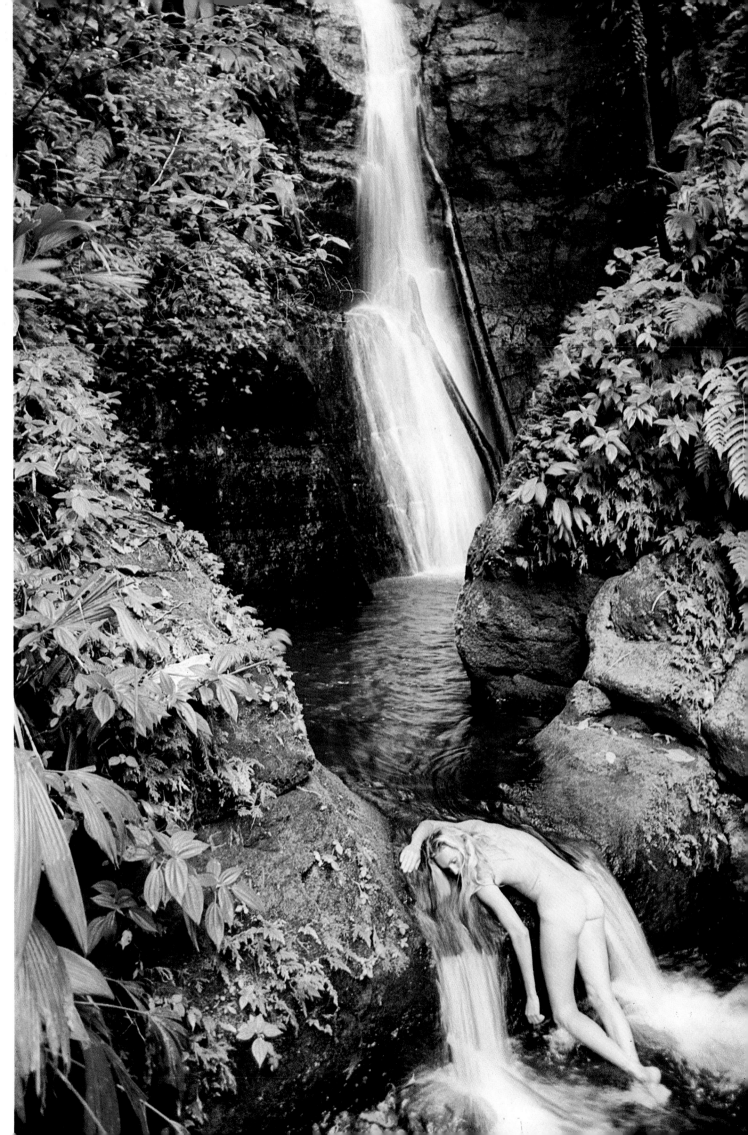

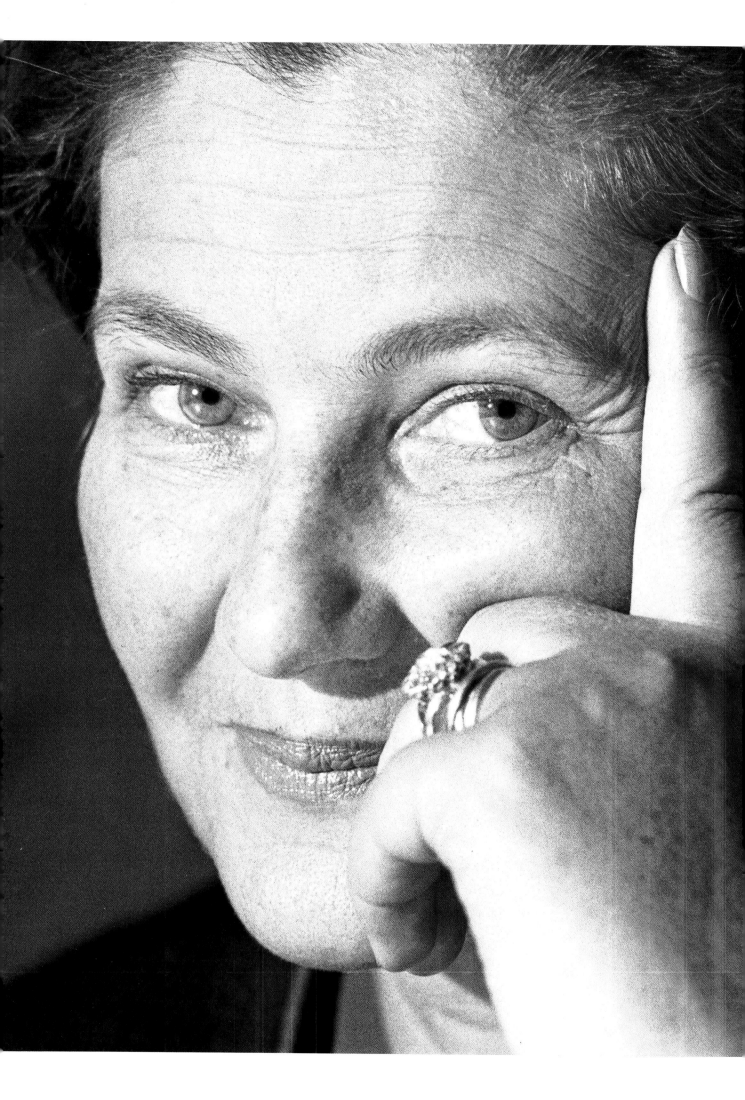

MADAME SIMONE WEILL
Sam White

At forty-nine and a mother of three, Madame Simone
Weill is not only one of the few women to have held
full cabinet rank in a French Government but is also,
as repeated opinion polls continue to show, the most
popular political figure in the country. She has been
Minister for Health since 1974 when Giscard
D'Estaing,on becoming President, plucked her out
from a distinguished but near anonymous civil service
career. Her greatest achievement in that post was to
steer through Parliament a bill legalizing abortion
in what is still a predominantly Catholic country. At
one point during the debate, when a right-wing
deputy denounced the bill as being worthy of those
who built concentration camps such as Auschwitz,
she blushed scarlet with indignation and almost
burst into tears.

Her emotion was understandable as she herself
was imprisoned during the war precisely in
Auschwitz and still bears her tattooed prison-
number on her arm. She is, of course, a Jewess born
Simone Jacob and her brother, father, and mother
died in concentration camps. In 1946 she married a
fellow student, Antoine Weill, who also became a
distinguished civil servant and now sits on the Board
of Air France. She became a magistrate at twenty-six
and later an Assistant Public Prosecutor at the
Ministry of Justice. It was at this time that she came
to the attention of President Pompidou who
promoted her to a still higher post in the ministry's
hierarchy. Her political sympathies, like those of her
husband, were strongly Gaullist and both
campaigned for official Gaullist candidates who
stood against Giscard in the 1974 elections.

She's strikingly good-looking with high cheek-
bones and green eyes and dresses well. A woman of
great culture and unfailing good taste, as well as
considerable intellectual discipline, she is now
spoken of freely as a possible, indeed likely, future
Prime Minister.

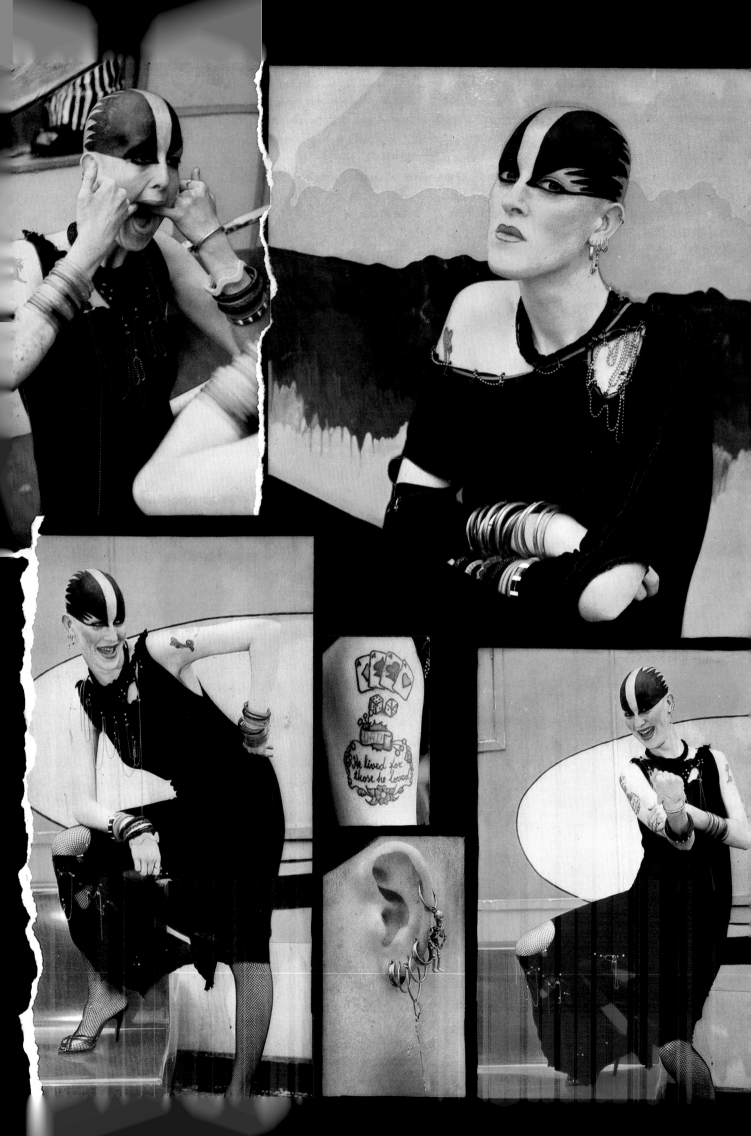

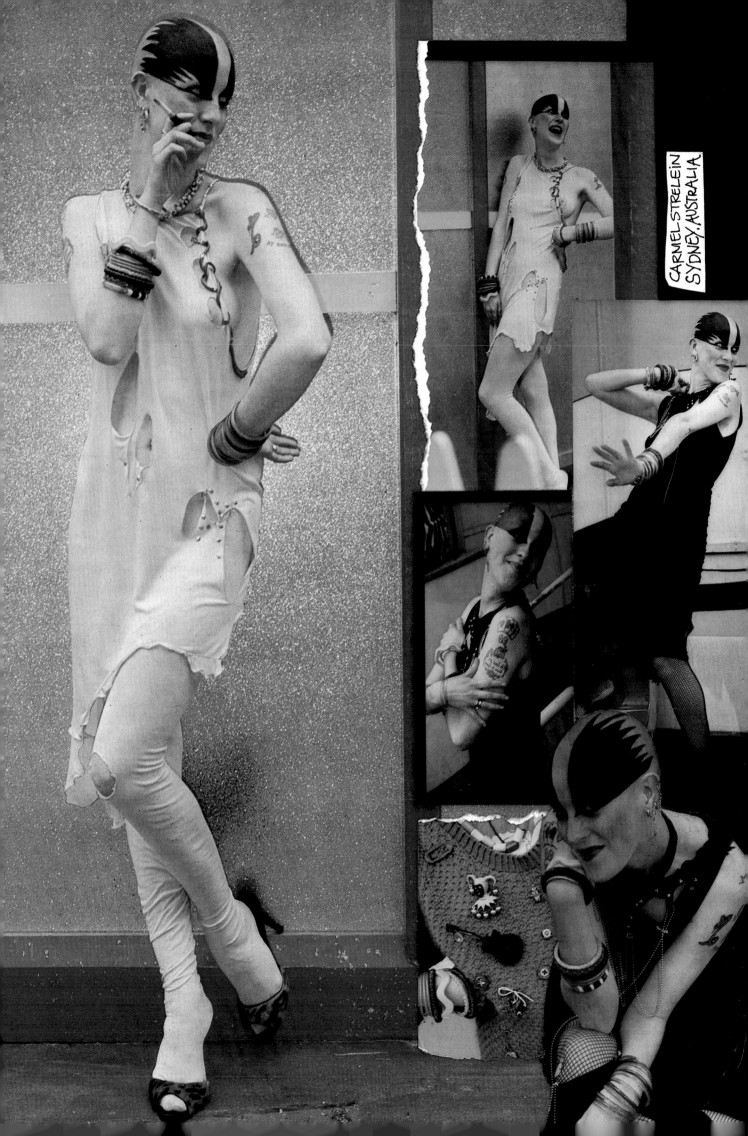

CARMEL STRELEIN
SYDNEY, AUSTRALIA

ERIN PIZZEY
David Astor

'She could do anything – I really think there's nothing she couldn't do.' It was said of Erin Pizzey by one of 6,000 women who have found refuge with her, the so-called 'battered wives', victims of a danger that society has not wanted to know about.

Erin's refuge has long been a ramshackle house on the Chiswick High Road called Chiswick Women's Aid. It was started in 1971, the first refuge from domestic violence there had ever been. It would probably have been closed early on, but for the protection of some newspaper publicity. Since then, many other refuges have been opened, here and abroad. But there is still no other in Britain which will take in and keep anyone for as long as they require.

Because she will keep anyone in need, many of the most violence-prone families end up at Chiswick. Erin has come to specialize in these very difficult cases. The mothers are often both frightened and themselves violent, with children sometimes showing the first signs of criminal behaviour. The mother was usually herself knocked about as a child and has instinctively chosen a husband who treats her and her children as she was used to being treated.

How does Erin come to have such an interest in these families and such an insight into how to deal with them? The answer is that she came from an unhappy violence-prone family herself. She speaks of having had to develop an acute 'awareness of the emotional temperature between her parents'; of having learned how to manipulate them so as to avoid unpleasant confrontations. Instead of being embittered, she developed a passion to rescue other families in the same situation.

In helping the families in her care to find a way out of their difficulties, Erin aims to create in the refuge a 'family-community', in which her dedicated staff play the roles of brothers and sisters. They help the mothers in all their problems with official bureaucracy but also try to show them by example new ways of coping with their families. Erin's own role is universal mother to everyone in the house, but she is well aware of the dangers of matriarchy and has regular house meetings with the character of a frank council.

Not even a violent father coming to the door is beyond Erin's sympathy – though she is quite capable of quelling habitually violent men by her fearlessness. And she has stood her ground just as bravely with local authorities. Her troubles with them have been due to one cause: her unwillingness to turn a mother away. She would rather go to jail than do that. It is as if to turn a distressed woman away would be to her like committing an act of treason.

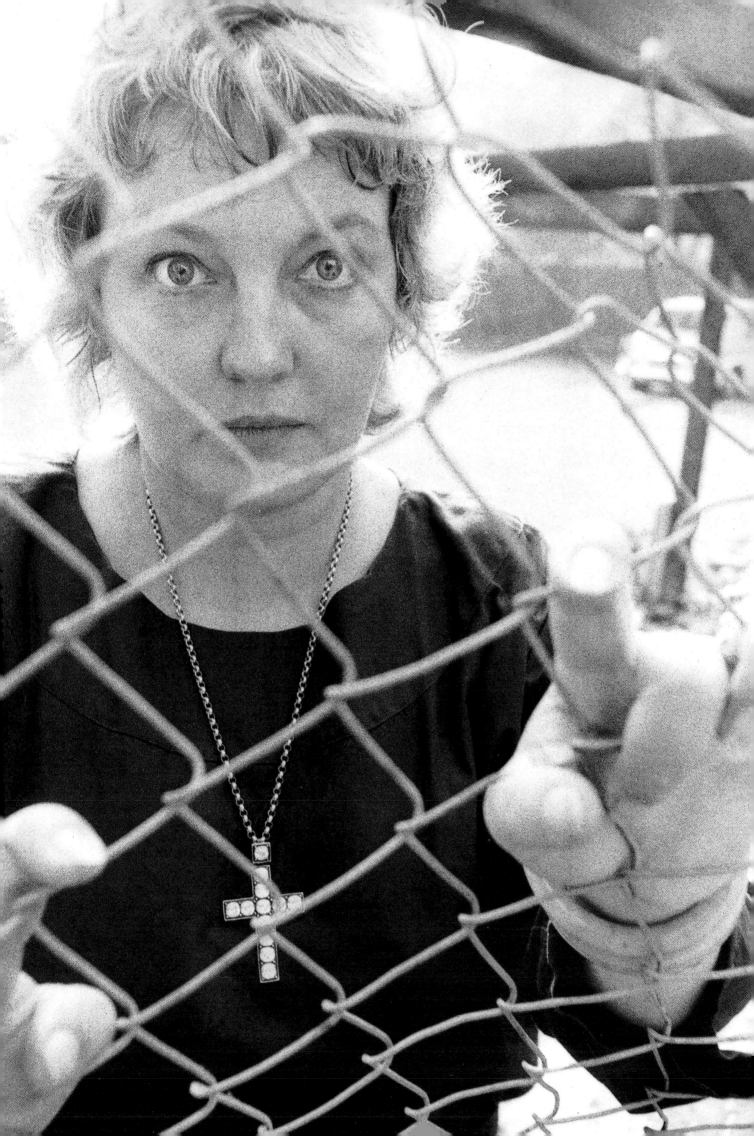

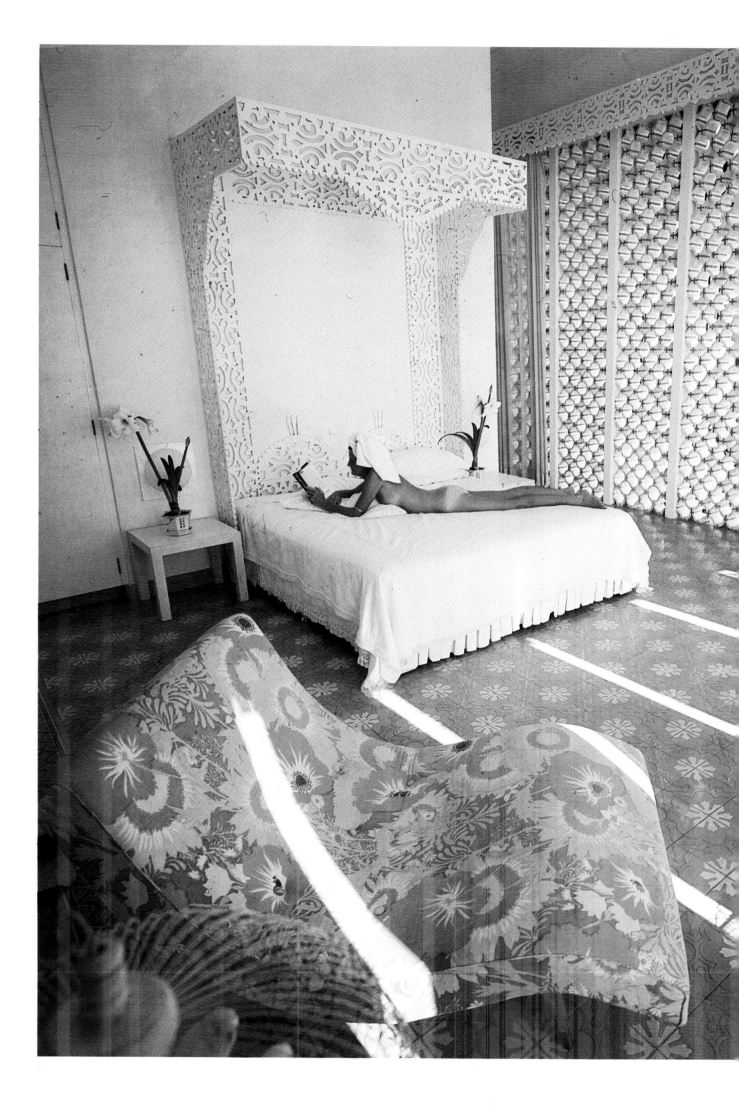

WENDA PARKINSON
Quentin Crewe

If you dare to think of Wenda – and it is an unsettling thing for any man to do in springtime, or any other time for that matter – two words come to mind. They are woman and liberation. But never together; on no account Woman's Liberation.

Wenda is the most perfectly attractive, wise, irrational, warm, canny, languid, laughing, sudden, graceful person. In short, woman – but to a degree which belongs, as a rule, in the realms of imagination.

Once she was a model, if you could call her that, because in reality she was so much more. A photographic inspiration would describe it better. The photographers looked at her and she freed them from the stilted conventions of their art. A new style of photographing fashion was born, more natural, more alive, more sensual – Wenda was the liberator.

For hers is a natural style. Everything is most carefully done – her hair, her skin, her hands most diligently cared for; but you would never know it, nor, more important, even sense it. You feel only the freedom – her hair laughing in the wind, her eyes as wide as a birthday present, her clothes as carefree as a butterfly wing.

Now she is a wife, for the best of those photographers loved her. Again, you wouldn't call it that. Not just a wife, but a heavenly creature who lives for him, completing his life. She travels, she goes racing in Trinidad, she writes her book (in an easy, natural style) on Toussaint L'Ouverture. But first and foremost she is Mrs Norman Parkinson and she is happy. And, just occasionally, the rest of us dare to think of her.

ELISABETH FRINK, C.B.E., R.A.
Laurie Lee

Lis Frink is in many ways her own work of art; a vibrant presence of sleek steel and beauty, of animal simplicity, grace and power. Since she first came to London as a slim taut student of eighteen, she has radiated this quality which friends and critics immediately recognized— a unique creative force wrapped in a capsule of innocent common sense.

As she moved amongst us, tough, lithe, helmeted with glowing hair, warm-hearted, uncomplicated in her confidence, she spun-off from her persona a whole world of sculptured myths and images which belonged to no one but herself and to which no other artist could possibly lay claim.

It is her knowledge and instinctive translation into form of the uncompromising and unsentimental spirit of wild animals, bird, horse, and man, that places her work separately from others. All her images enjoy the liberty of their own selves, be they hog, crow, vulture, bull, rabbit, or the basilic semigodlike stare of her large inscrutable male figures. Yet, as they are separate but often joined together as birdman, horseman, or vulture riding the back of a bull, so do I see in all her work, even in the most delicate drawings of hare and lynx and leopard, the still brilliant glint of Lis Frink's own exceptional eyes and genius.

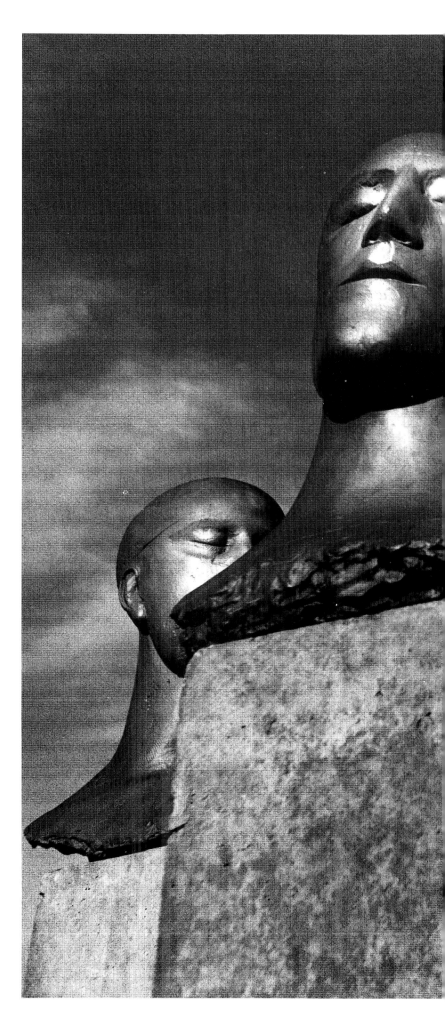

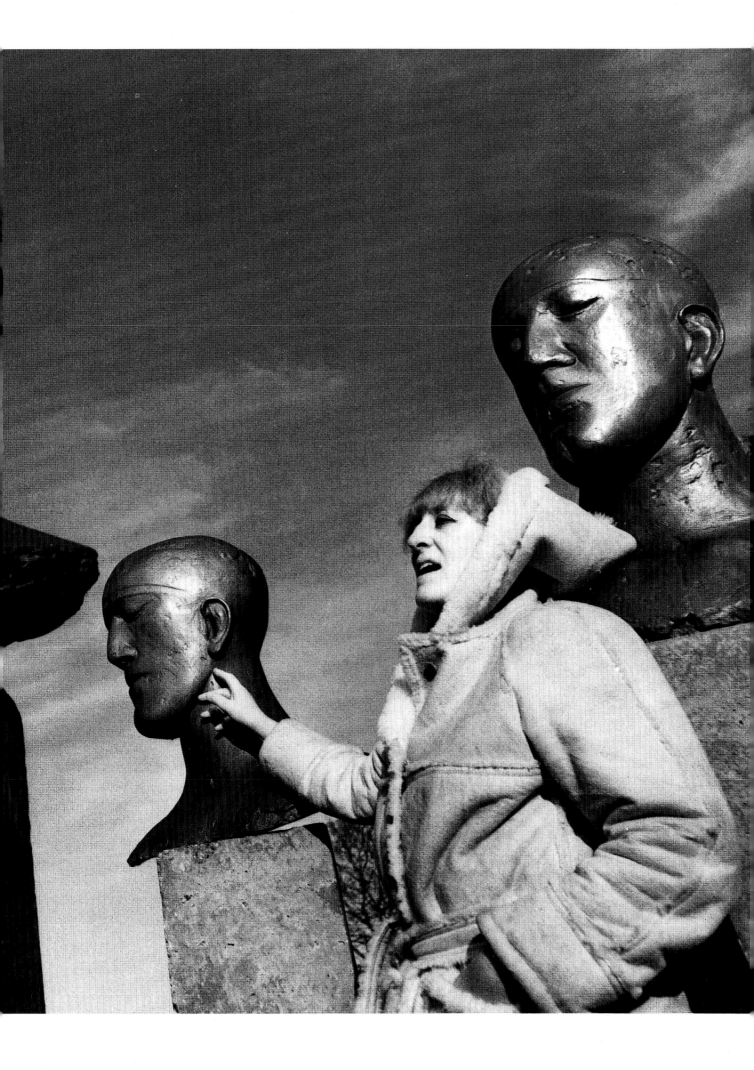

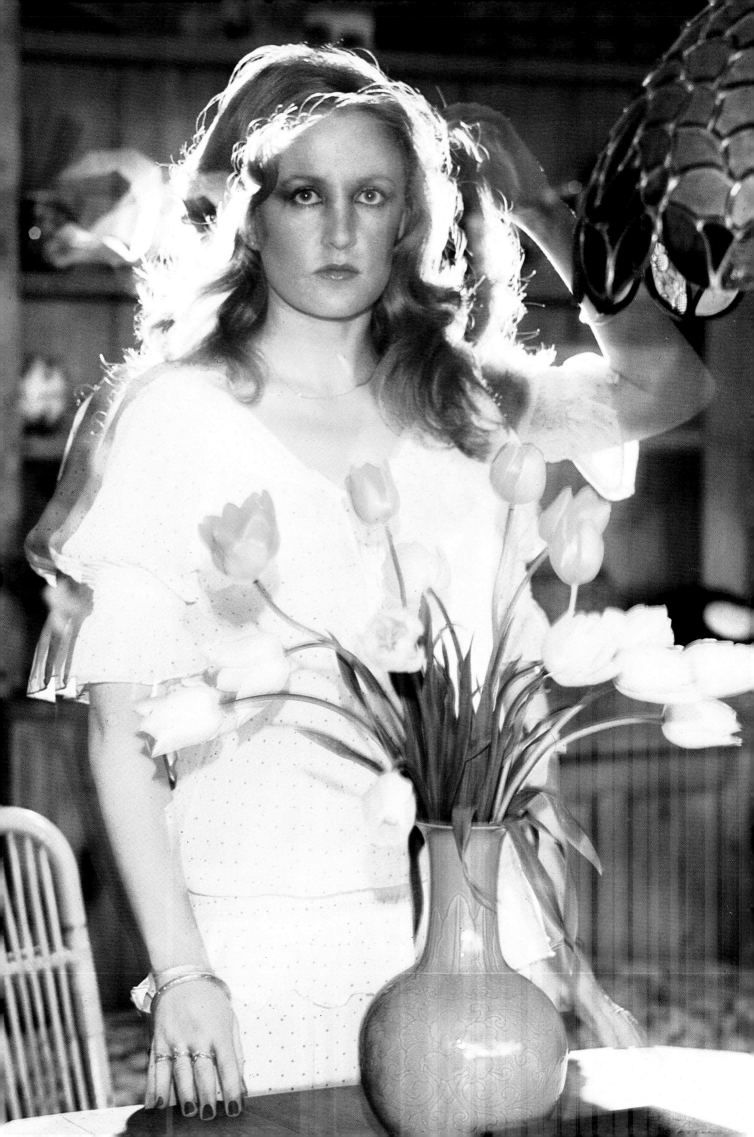

MAMIE EISENHOWER

For many people today, it takes an effort of historical imagination to grasp the kind of person Mamie Eisenhower is; and this fact is a measure of something valuable we have nearly lost.

She is a lady, not only of style, but of great decorum.

Just think back a little. She was the wife of a West Pointer. During the 1920s and the Depression, career army officers — and their wives — were not heroes of the American people. Their pay was bad, promotion incredibly slow, life a succession of military bases in obscure corners of the world in which virtually no one was interested.

Then, almost overnight, Dwight D. Eisenhower became one of the most powerful men in the world — and remained so for nearly two decades. Supreme Commander, Allied Forces in Europe. First Commander of NATO. President of Columbia University. Then President of the United States for eight years.

Think back about those twenty years before the Second World War. Twenty years coping with obscurity. Then think about the next twenty years. Coping again. How many wives could have stayed the course and made the transition?

In her spare time, of course, Mamie had to take the major responsibility of rearing a young man named John. She apparently did a good job at this too, since John later served his country as Ambassador to Belgium among other things.

But what kind of a person is Mamie Eisenhower really?

She is totally feminine. She is absolutely a lady. And she has that almost vanished quality of decorum.

Put simply, Mamie has always known when to step forward and when to step back; when to occupy centre stage and when to retire to the wings. A rare quality these days.

Perhaps above all, Mamie is a great American lady. The pioneers must have been much like her: unfailingly cheerful; generous and warm-hearted; decisive; and always knowing exactly what she wants.

There could be no higher accolade than to say that she personifies what all Americans envisage as a lady we love for what she is, for who she is, and for what she inspires in each of us.

SOPHIA LOREN
Barry Norman

I suppose, to be realistic about it, that like everyone else Sophia Loren must consist of male as well as female hormones, though when you look at her it does seem unlikely.

The other great beauties and sex symbols of the movies tend to be ice-maidens, like Garbo, or simply grown-up little girls, like Monroe and Bardot, but Loren always seems to me to be about 150 per cent woman. At various times, in films like 'Two Women' and more recently 'A Special Day', there have been forlorn attempts to make her look dowdy, but it just can't be done.

The splendid sweep and curve of her body can be disguised under a shapeless dress, but it's impossible to hide the boldness and utterly feminine confidence of those huge, feline eyes and that wide – and to male fantasy, passionate – mouth.

In the unlikely event that a visitor from Mars should ever ask me to show him someone who represented total rich, ripe femininity, I would direct him immediately to Sophia Loren in the utmost confidence that, no matter what her Martian equivalents looked like, they would never satisfy him again.

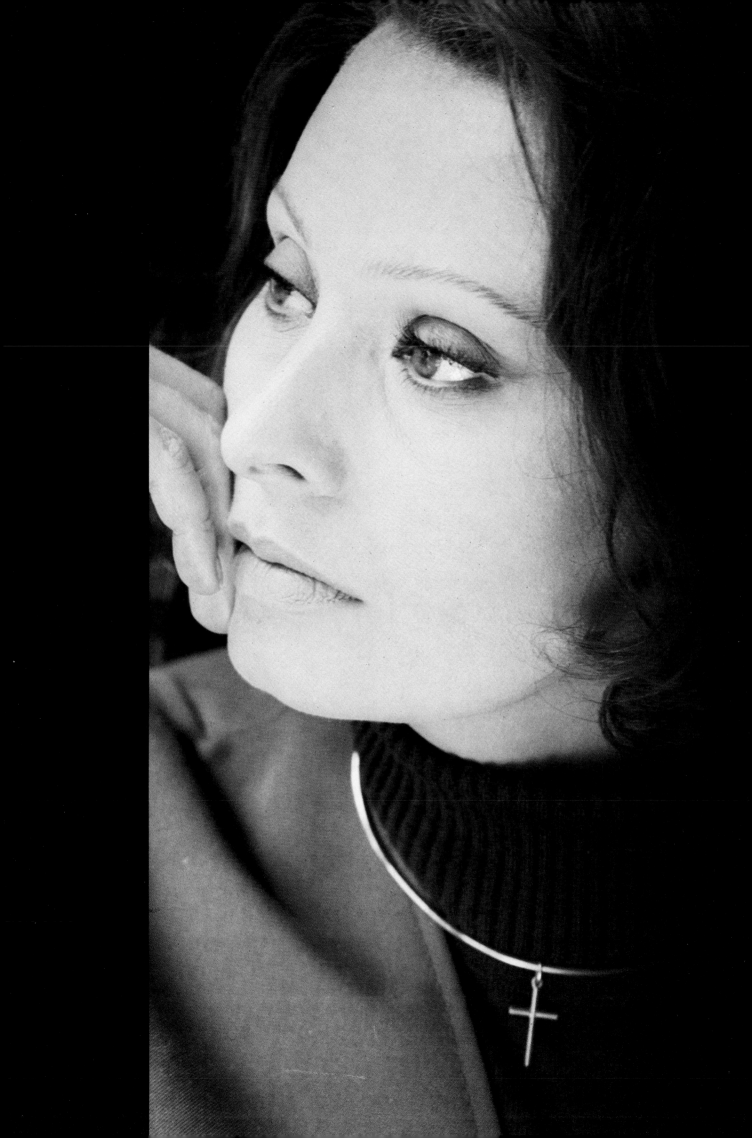

DAME EDITH EVANS

Christopher Fry

When I was about to start work on a play, 'The Dark is Light Enough', for Edith Evans, she came to visit my wife and me in a farm-labourer's cottage in the Cotswolds which we rented for six shillings a week. I remember we took her for a long walk across muddy fields (she had bought a pair of gum-boots in Burford before we set out) to look at a tiny ancient church. When we got home we sat by the fire of the old-fashioned cooking-range, and in the course of conversation I said how sorry I was never to have seen her play Rosalind (at the Old Vic in 1936–7). As we talked she began to speak some of Rosalind's lines; the years dropped away – she was already in her sixties – and there was the very girl, the spirited witty Rosalind, sitting beside our fireside.

It was over the roof of this cottage that Peter Brook, who was to direct the play, threw eggs to test my theory that fresh eggs could be thrown over the roof and land on the patch of grass at the back without breaking. The theory proved to be true.

Not long before we started rehearsing 'The Dark is Light Enough', one of the characters was still uncast, though it was thought Wilfred Lawson might be playing it. I asked Edith whether she knew and liked him. 'I can never remember,' she said, 'whether I like him very much indeed or don't like him at all, but I DO remember that he named his bicycle after me'.

She was a great dear as well as a great actress. When we took her to Ostia Antica, outside Rome, she stood in the open-air arena, while we sat at the farthest limit of the amphitheatre. She spoke Portia's 'The quality of mercy', and every syllable came soaring and clear through the blowing of the wind and the noise of the passing traffic.

Oliver Messel

My first experience of dressing dear Edith was especially happy. Gilbert Miller intended to produce Wycherley's 'The Country Wife' on Broadway for the brilliant American actress Ruth Gordon. When he approached me I said at once that I would be delighted to undertake the designs if the production could be directed by Tyrone Guthrie, who to me was one of the most inspiring directors: especially inventive over the light-hearted but skilful manipulation and style required for Restoration comedy.

Guthrie was at that time engaged at the Old Vic and the production was somehow manoeuvred to be presented there first, for a limited season. He set about gathering a flawless, all-star cast, headed by Edith as Lady Fidget. Michael Redgrave appeared in one of his first leading roles as Mr Horner; Ursula Jeans, with superb style and porcelain beauty, as Alithea. Freda Jackson was the maid. The opening was sensational and the notices superlative.

Edith's buoyant command of the stage swept all before her, yet not so as to eclipse, but enhancing the performances of Ruth Gordon and the rest of the dazzling cast. This perfection of style was painfully lacking when Gilbert Miller for New York dispensed with Guthrie's personal direction. Without Guthrie's guidance and spontaneous magic touch, without Edith and the whole inspired team, the play became an insufferable bore.

It was always a wonder how, with a face entirely asymmetric, one eye drooping and no features that could be considered a natural asset, she could by self-hypnosis mould herself, so that if she chose she could appear on the stage as a radiant, compelling beauty.

Edith to me was never temperamental or difficult about her costumes for the stage or screen. She naturally studied and discussed her appearance carefully, but then she would have complete confidence and leave herself entirely in my hands. Fittings with Edith were always fascinating, as she would instantly become whatever character she was about to play.

I remember how, in her first big film role, as the aged Countess Ranevskaya in 'The Queen of Spades', without a word of complaint she submitted to the ordeal, however painful, of having her skin shrivelled into that of a wrinkled old crone. But even apart from the make-up, she would somehow shrivel herself down into the billowing fur wraps and instantly arouse one's protective instincts towards such an aged and frail being.

While 'The Dark is Light Enough' was in preparation, Alec Guinness went to tea with Edith. He told me that he was quite baffled at first, as all the time she was moving around the room she was leaving imaginary space – for the crinoline dresses she was to wear in the play.

To design for the most exquisite young beauties can be disappointing in this age, because they seldom know how to move or even walk in period costumes. Therefore to design for an actress of such professional experience and artistry as Edith was always the greatest joy.

SUGAR BUM

Aldwyn Roberts ('Lord Kitchener')

Audrey, where you get that sugar?
Darling, there is nothing sweeter.
You make me squeel, you make me bawl,
You make me feel like ten feet tall.

Chorus:
Sugar bum, sugar bum, bum,
Sugar bum, sugar bum, bum,
Sugar bum, sugar bum, bum,
Sugar bum, sugar bum, bum.

Audrey, every time you wriggle,
Darling, you put me in trouble.
You torture me the way you whine.
I love to see your fat behind.

Chorus:
Sugar bum, sugar bum, bum,
Sugar bum, sugar bum, bum,
Sugar bum, sugar bum, bum,
Sugar bum, sugar bum, bum.

Darling, I don't want to lose you,
Honey, like you give me voodoo.
Gi' way my land, gi' way my car,
But let no man touch my sugar.

With our affectionate acknowledgement
and thanks to the mighty 'Lord Kitchener',
calypsonian extraordinary of Trinidad,
whose song it is.

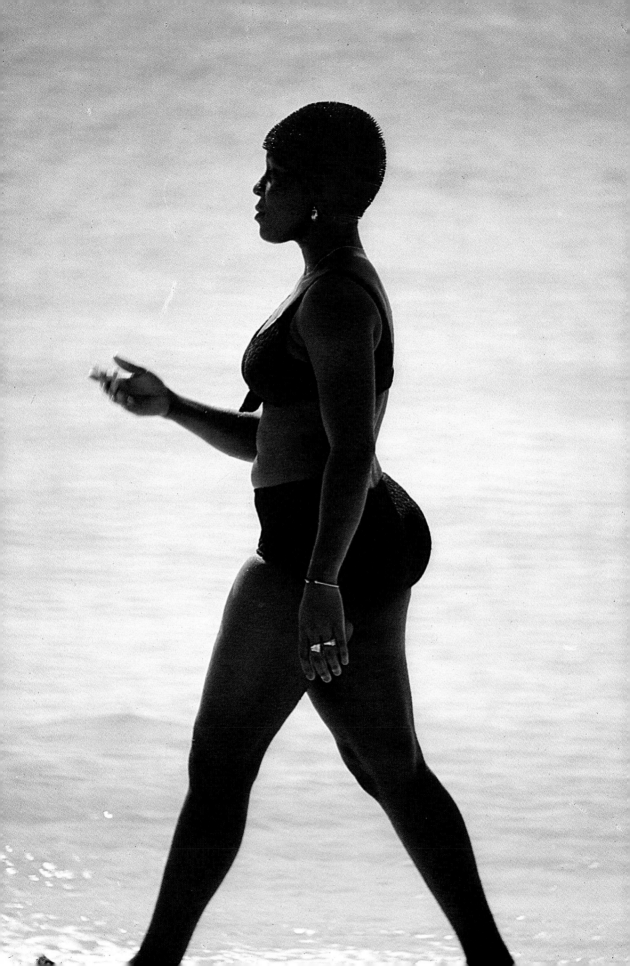

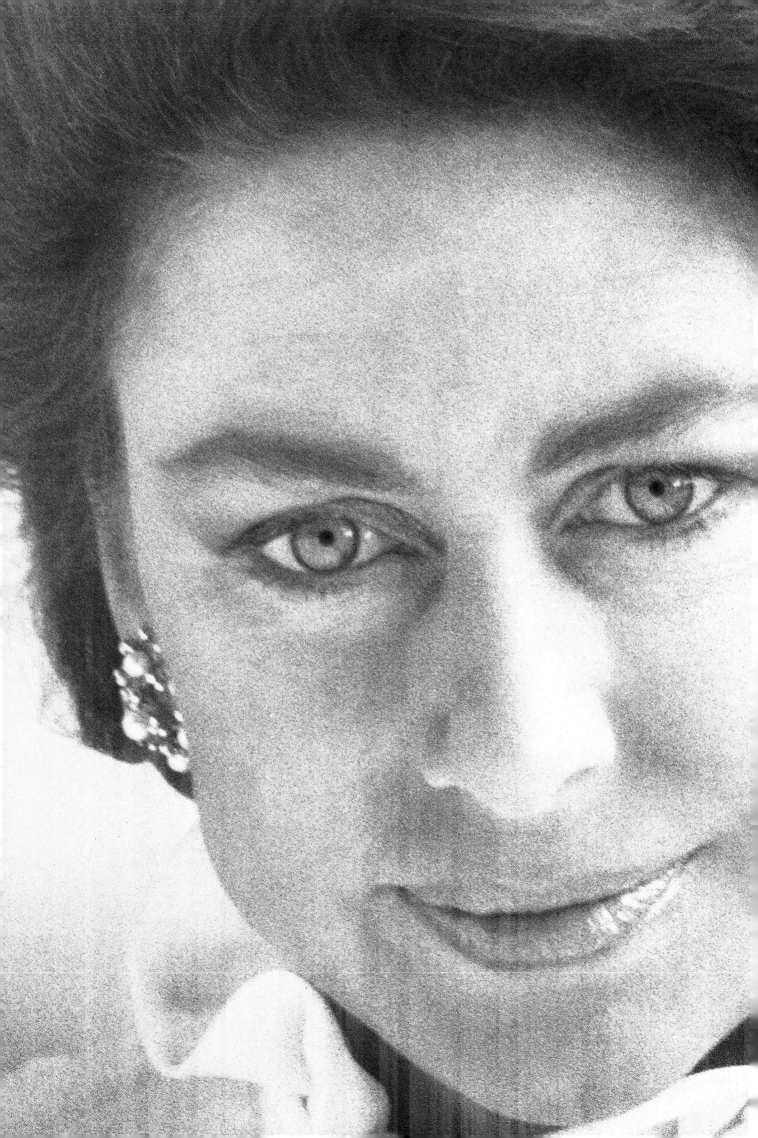

H.R.H. THE PRINCESS MARGARET

Nigel Dempster

She drinks gin and tonic in the morning, whisky and soda at night, chain-smokes cigarettes through a tortoiseshell holder, wears heavy make-up and tight dresses, prefers the company of the young and talented to that of her contemporaries, stands heavily on ceremony and protocol, relaxes by playing the piano and singing and is a devoted mother.

Princess Margaret Rose of York was born in the middle of a torrential storm in historic Glamis Castle, home of her maternal grandfather, the Earl of Strathmore, and found herself, at the age of six, unexpectedly the younger daughter of the King of England and sister of the future Queen.

She adored her father – she made him laugh and used to help him relax by playing the piano for him – and filled the void after his death by developing an affection, which turned into love, for his handsome equerry, Group Captain Peter Townsend.

If her father had not died, he would have seen her married to Johnny Dalkeith, now the Duke of Buccleuch, say friends, and the sad Townsend saga would never have been. Instead, the hopeless passion existed for three and a half years, much of which was spent apart, before the full weight of The Establishment was brought to bear on the situation and end the dalliance.

Chafing at the restrictions placed upon her, and made to feel extraneous because of her situation as the younger child, the Princess made a beeline for Bohemia, became friends with Louis Armstrong and Duke Ellington, danced the night away in West End clubs and, eventually, met a failed architect who had become a society photographer, Anthony Armstrong-Jones.

After a two-month Caribbean honeymoon aboard the Royal Yacht 'Britannia', the couple settled into a grace-and-favour apartment in Kensington Palace, produced two children, but did not live happily ever after, officially separating in March 1976.

Margaret is well-informed, amusing, a marvellous mimic and a thwarted actress. She needs to be entertained and likes to entertain – at Kensington Palace parties she has sung duets with Frank Sinatra and accompanied composer Sammy Cahn at the piano.

She says she has no ambition and carries out an average of three royal functions a week, relaxing every winter with a three-week holiday at her villa on the Grenadine island of Mustique, built on a plot of land given her as a wedding present.

She is now divorced, but says that, in any case, she will not marry again – her sister, of course, being the Defender of the Faith and head of the Church of England.

And like many rich people she is financially very prudent, economizing whenever possible. She says she cannot afford a country home and spends weekends with her mother at Royal Lodge, Windsor, instead.

BARBARA CARTLAND

A phenomenon and a legend in her own time. At seventy-seven has written nearly 300 books, the only author ever to have 45 million books in circulation in the United States at the same time. Eighty million over the world. She wrote twenty-four books last year, breaking her own record of twenty-two the previous year.

Changed the law with her gypsy campaign and instigated a government inquiry into the conditions of old people. Served thirty-five years in the St John Ambulance Brigade, a Dame of Grace of St John of Jerusalem and one of the first women, after a thousand years, to sit on the Chapter General.

Is meticulously organized, runs her house like a factory with four full-time secretaries and six subsidiaries. Is awe-inspiring, although she says:

'I hate people who are frightened of me!'

Has been deeply interested in vitamins since working in the distressed areas in the 1930s, in malnutrition and habitual abortion. Answers 10,000 letters a year on health problems.

Never works at week-ends because her very closely-knit family is with her. Has always made 'Family First' her motto. Had twenty-seven years of perfect happiness with her husband, by whom she had two sons, but the inspiration of her life was her brother Ronald, a visionary, the first Member of Parliament to be killed in the Second World War.

Believes women should be glamorous, dresses to please herself and her fans, mostly in 'Cartland pink', with feathered hats. Has very positive opinions on women, in direct opposition to 'Women's Lib.'. Believes in reincarnation, and that love must be spiritual as well as physical and young women should be virgins until they marry. Loathes pornography, ugliness, beige, bad manners, smokers, men with beards and dirty shoes.

Barbara Cartland

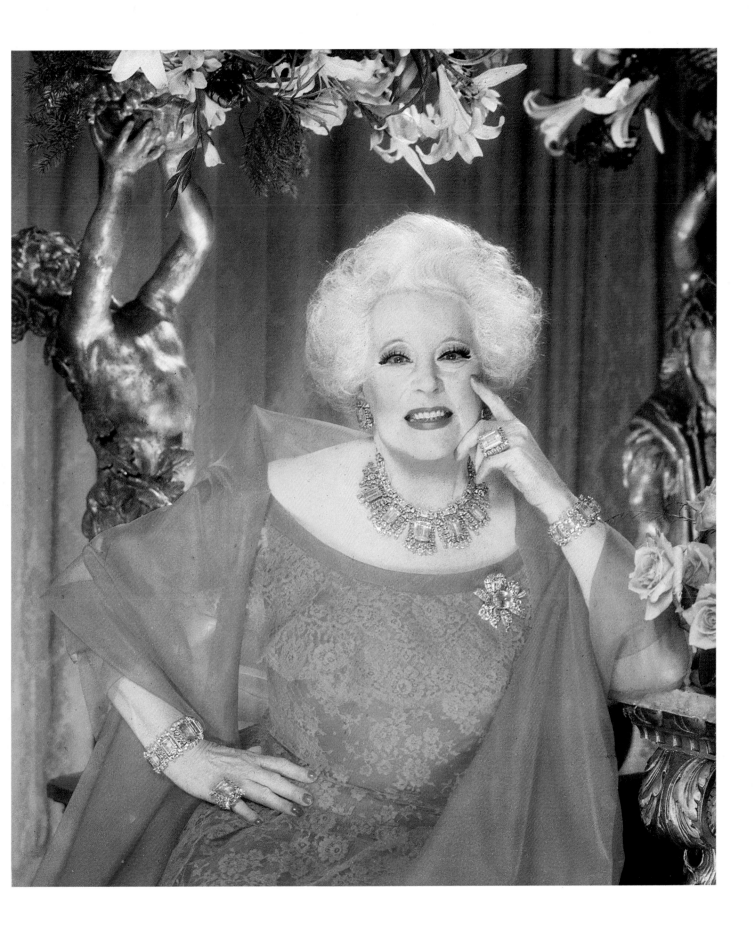

VANESSA REDGRAVE
Naim Attallah

Vanessa as the beautiful, outrageous Isadora Duncan embodies today the passion of that great star of a past, exciting era.

I wish I had known Vanessa twenty years ago. Her fire would have kindled the revolutionary in me, perhaps the more so since youth demands change in terms rejected in later years when compromise replaces idealism and conformity becomes an integral part of day-to-day living. Vanessa has not mellowed, she has walked miles through bleak streets between hostile or indifferent crowds, carried the banner of revolution, defied the Establishment, taken up dramatic positions on burning issues, and yet throughout she has retained a shyness tempered with gentleness and compassion seldom seen in women with a cause.

Her concern has been for humanity at large, rebelling against want, injustice, inequity, and embracing all that is sacred to the Left. As a woman she has loved, been loved, experienced most of the pains and joys of womanhood. She has aspired to great heights and scaled some of them. She has inspired many to follow her and equally instilled awe and apprehension in others. She is discussed and remembered, admired; and to the converted she represents the epitome of courage born of conviction.

Number 13 Cemetery Road, Marie Galante, Petites Antilles.

ACKNOWLEDGEMENTS

My thanks to H. S. Williamson, Art Master at Westminster (1928), who taught me how to see;
to Mr Smart of Speaights (1932), who taught me how to print;
to Alan McPeake, Art Director of British 'Harper's Bazaar' (1935),
who taught me how to take photographs that fitted the page;
to John Parsons, Art Director of British 'Vogue' (1950),
who taught me how to make women beautiful;
to Bettina Ballard, Fashion Editor of American 'Vogue' (1951), who defined 'pezazz';
to Alexei Brodovitch, Art Editor American 'Harper's Bazaar' (1954), whose advice I never forget;
to Diana Vreeland, all-time doyen of the fashion world,
who taught me that a camera must spread joy and delight and sunshine and happiness (1960);
to all the 'Vogues' for whom I took some of the photographs;
to so many hard-working and talented assistants who have helped me through the years—
David Searle, Peter Gough, Barry Weller, Tim Jenkins , Graham Lawrence and currently Robert Pascall;
to Norman Brand for his black and white printing,
Paulo for his colour processing;
to Olivier Echaudemaison, from Harriet Hubbard Ayer, Paris, who has the other secret of beauty with
make-up; and to Kerry Warn of Molton Brown, who is unsurpassed as a hairdresser—he is a genius.
To Pam Shand of Quartet who did most of the work and kept her cool and of course Michael Jarvis
for the excellent artwork.